T0261094

Museums in a Digital Culture

Museums in a Digital Culture

How Art and Heritage Become Meaningful

Edited by
Chiel van den Akker and Susan Legêne

Amsterdam University Press

Cover illustration: Photograph of "Rain Room" by Random International, at The Curve, Barbican Centre, London 2012; with kind permission of Random International

Cover design: Coördesign, Leiden
Lay-out: Crius Group, Hulshout

Amsterdam University Press English-language titles are distributed in the US and Canada by the University of Chicago Press.

ISBN	978 90 8964 661 3
e-ISBN	978 90 4852 480 8 (pdf)
DOI	10.5117/9789089646613
NUR	657

Creative Commons License CC BY NC ND (http://creativecommons.org/licenses/by-nc/3.0)

Ⓒ Chiel van den Akker & Susan Legêne / Amsterdam University Press B.V., Amsterdam 2016

All rights reserved. Without limiting the rights under copyright reserved above, no part of this book may be reproduced, stored in or introduced into a retrieval system, or transmitted, in any form or by any means (electronic, mechanical, photocopying, recording or otherwise) without the written permission of both the copyright owner and the author of the book.

Every effort has been made to obtain permission to use all copyrighted illustrations reproduced in this book. Nonetheless, whosoever believes to have rights to this material is advised to contact the publisher.

Printed and bound by CPI Group (UK) Ltd, Croydon, CR0 4YY

Contents

List of Figures

Introduction

Museums in a Digital Culture: How Art and Heritage Become Meaningful

Chiel van den Akker and Susan Legêne

With museum-based case studies as a starting point, this collection of essays addresses the overall changes in the access to and experience of art and heritage in our digital culture. Information and communication technology is changing the museum on different levels. It changes the relations a museum maintains with other institutions and organizations, methods and practices of collection management, and the relation that museums maintain with an increasingly diverse public. The use of information and communication technology affects means of display, research, and communication and may involve issues of power and authority, of ownership and control over access to heritage and information, both physically and intellectually.

Apart from being cultural institutions that collect, store, and exhibit artefacts with a significant aesthetic, historic, cultural, or scientific value, museums are places in which, over time, artefacts acquire and change meaning as a result of the triangular relationship between artefact, the way it is displayed, and the affective and cognitive response of the audience. The very fact that today's museums – or at least those museums that are located in postindustrial societies – operate in a digital culture, implies that this process of meaning-making involves a growing variety of uses of information technology. The case studies in this volume address this development, ranging from the relationship between on-site and online visits, to immersing oneself in a digital mediated art installation, and from recoding the existing collection to hosting a virtual mnemonic community.

Two themes run through this approach to museums in a digital culture. The first is a discussion of new modes of sensory experience that are offered by information technology in on-site and online museums with respect to displays of both existing and new works of art and heritage objects. The second investigates the new knowledge infrastructure provided by information and communication technology, which extends the role of museums as cultural institutions and as "hosts" for new communities. These two themes resonate through all the essays in this collection; the first does so more prominently in the first part, the second in the last chapters. The case

studies thus specifically zoom in on museums in a broader reflection on the question of how art and heritage become meaningful in a digital culture.[1]

In addition to offering new tools to visualize objects, information technology supports new modes of experiencing and perceiving art and artefacts, and this requires a specific vocabulary. This volume argues that the experience and understanding of art and heritage in a digital culture are best understood in relation to a series of related concepts: interaction, haptic experience, *ekphrasis* (the description of an object or artwork that evokes its image), immersion, "thinking with the eye" (curiosity), and the image as interface. This focus on experience and perception inscribes the museum in contemporary visual culture while at the same time it questions the ocular centrism of Western culture inasmuch as it departs from the conception of art and artefacts on display as "things to be looked at." Over the past decades, the visitor has gone from being a passive observer to being a user (someone who interacts with the object) and participant (someone who is involved in the meaning-making process of art and artefacts). Information and communication technology strengthens this development, not only on-site, but increasingly also in online display, and this obviously affects the museum professional preparing an exhibition and designing displays, the artist making a work of art, and the person visiting the museum.

With some telling examples, this volume shows how the new knowledge infrastructure of on-site and online museums provided by information and communication technology redefines what we take to be objects and collections, allowing new forms of curation and co-creation within the museum space. The new knowledge infrastructure may challenge existing power relations and offer opportunities for new forms of self-representation and communication. It is no longer self-evident that museums reflect and reinforce established frames of classification and interpretation developed in art history, ethnology, archaeology, and other academic disciplines. Information technology strengthens the ease with which master narratives are broken open, and it may multiply the possible relations between art and artefacts from different times and places, both on-site and online. The

1 There is an abundance of literature on art and heritage in the age of new media, showing a wide variety of interests and concerns. See for example the essays assembled by R. Parry ed., *Museums in a Digital Age* (London: Routledge, 2010). The two themes that run through this collection follow a path laid out by Eilean Hooper-Greenhill and others. See in particular E. Hooper-Greenhill, *Museums and the Interpretation of Visual Culture* (London: Routledge, 2000). Recently, and further down the path, attention to the experiential and affective appeal of artefacts in museums in relation to new media is emphasized by Michelle Henning and others. See M. Henning, *Museums, Media and Cultural Theory* (New York: Open University Press, 2006).

museum in a digital culture is what Eilean Hooper-Greenhill has called a post-museum, a site of mutuality rather than a site of authority, where the museum is the visitor's partner in the creation of meaning,[2] hosting on-site and online communities. In a digital culture, museums work *with* rather than *for* their community.[3]

Against the backdrop of these two themes, we will now briefly introduce the individual essays and anticipate the general conclusion that can be drawn from them.

Digital technology offers new sensory experiences and may invoke affective responses to works of art and artefacts. These are examined by Martijn Stevens in what he refers to as haptic experiences, a concept that enables him to explain intuitive and affective surfing, interaction with digital content, immersion, and the epistemic shifts that these activities bring about. Where optic vision is characterized by distance and disembodiment, haptic vision is the "experience of proximity in terms of affinity, connectivity, and attraction." This haptic experience does not necessarily depend on the material presence of an object. Using the Tate website as an example, Stevens explains the centrality of the haptic experience in digital driven environments by referring to the power of the database, which "consists in the possibility of establishing multiple connections between items that are historically and geographically far removed." Stevens emphasizes, like Beaulieu and De Rijcke in their contribution to this volume but in the different vocabulary of haptic experience, that the image functions as an interface, that is, "as a link or a passageway to a diversity of associated objects, people, and events."

Starting with a description of Camille Utterback's and Romy Achituv's interactive installation *Text Rain*, which requires physical and imaginative participation, Cecilia Lindhé observes that we need to rethink the relation between descriptions and artefacts. Therefore Lindhé closely examines the notion of ekphrasis, the (poetic) description of an object or a piece of art with the goal of evoking its image, and argues that the ancient oratory or rhetorical concept of ekphrasis is better suited to account for digital installations than its modern equivalent. This is so because the rhetorical concept of ekphrasis emphasizes the *effect* of evoking images on the audience. In what Lindhé refers to as digital ekphrasis, the process of visualization is central and emphasizes how installations with their combination of visual, verbal,

2 Hooper-Greenhill, *Museums*, xi.
3 S. Bautista, *Museums in the Digital Age: Changing Meanings of Place, Community, and Culture* (Landham: Altamira Press, 2014), 27.

auditory, and kinaesthetic elements afford multisensory, participatory, and vivid experiences. Her argument thus supports the analysis of experience presented by Stevens.

The haptic experience introduced by Stevens is further explored by Christina Grammatikopoulou in the context of installation art. Grammatikopoulou, taking a phenomenological approach, discusses four interactive artworks – Char Davies's *Osmose*, George Khut's *Cardiomorphologies v.2*, Christa Sommerer's and Laurent Mignonneau's *Mobile Feelings II,* and Thecla Schiphorst's *Exhale* – which all "come to life" through controlled body movements. These interactive installations provide biofeedback, making use of motion tracking technology measuring breathing rhythm, temperature, and/or heart rate. This allows Grammatikopoulou to emphasize "the role of the public as co-creators of interactive artworks involving participation through the body." Interactive installations transform museums and other art spaces, according to Grammatikopoulou, into a new kind of art laboratory "where artists and visitors meet and create meaning together." Rather than being works to be admired from a distance, interactive biofeedback art reveals to the visitor/participant an inner space for self-reflection, making them aware of the unity of mind and body, as both Indian philosophy and twentieth-century phenomenology maintain.

Current developments in museums prompt us to reflect on how we relate to the past in a digital culture. Chiel van den Akker argues that although the use of digital technology may be innovative, the models used to present (art) history determine whether on-site and online (art) history museums are to be labelled "old" or "new." In a historical-philosophical critique of in context and in situ exhibition practices, he distinguishes between the classic chronicle and modernist master narrative and three alternative models to represent the past: the display of objects in small discontinuous historical series; the presentation of objects from different times in an order of co-presence; and displays evoking a sense of immersion into the past. Van den Akker argues that these three alternative models of presenting (art) history, while stimulating curiosity, favor the contemporaneous point of view above the retrospective point of view which is typical of historical narratives. It thus seems that in a digital culture, the insight of late eighteenth-century German Romanticism not to measure the past by contemporary standards – the founding insight of modern historical consciousness – no longer applies to the new on-site and online museum.

Anne Beaulieu and Sarah de Rijcke emphasize the importance of the database in understanding the multiple possibilities for (re-)ordering collections: "The database not only shapes much of the institutional work

processes within the museum, but it also (re)defines what counts as the collection and how other users can interact with the museum collection via digital images." Their central thesis is that digital images become active objects; rather than mere representations of objects to be seen, images function as interfaces. The image as interface explains its interactive functionality: it can be an interactive object of study in itself, allowing to zoom in and out for example, and most importantly through the metadata attached to it, it functions as a point of entrance to other aligned and networked images and information. As a consequence, it is the image as interface that determines what and how we know, resulting in what Beaulieu and De Rijcke describe as "windowed" and networked modes of viewing and knowing. New museum practices associated with the concept of images as interfaces are studied in the context of the ethnographic Tropenmuseum in Amsterdam. Combining new media studies and science and technology studies, they are able to connect new museum practices to contemporary visual and digital culture.

Serge ter Braake discusses the emergence of a mnemonic community "hosted" by the museum: the Digital Monument to the Jewish Community in the Netherlands, for which the Jewish Historical Museum in Amsterdam is responsible. The Digital Monument consists of a "canvas of colored dots" where each dot represents a victim of the Nazi genocide in the Netherlands during its occupation in 1940-1945. By clicking on a dot, the user is directed to the personal page of a victim with biographical information and (when available) a photograph. The monument thus is an interface which allows it in addition to function as an information provider. Ter Braake, who was an editor for the monument between 2007 and 2012, reflects on the many difficulties the project encountered, stemming from the tensions between "commemoration (which often is not helped by precision and objectivity), history (which aims at being precise and objective), memory (which often claims to be precise and objective, but is not), [and] the large set of data (which is not precise and does not claim to be so)." Interestingly, it was the unforeseen and overwhelming response of visitors who wanted to adjust and add information, indicate their relation with victims, or contact other visitors, that eventually turned the monument into a participatory, interactive, collaborative, and dynamic online mnemonic community.

Kate Hennessy starts from the other end from Ter Braake, taking a critical stance towards power relations implied in collections. She emphasizes the possibilities offered by information technology to share curatorial and ethnographic authority with Aboriginal communities, connect tangible and intangible heritage, and readdress issues of ownership, (virtual) control over, and actual or virtual repatriation of cultural property. Hennessy discusses

work she has done on the *Inuvialuit Living History* project, a virtual museum project of the Inuvialuit Cultural Resource Centre in Inuvik, Northwest Territories, Canada, in collaboration with researchers, curators, and media producers. The virtual museum uses the Smithsonian MacFarlane Collection and aims to reconnect this collection to the intangible heritage associated by the community with the collection's objects. Hennessy argues that such "digital ethnology" stimulates collaboration between researchers and originating communities, revealing power relations in ethnographic, curatorial, and digital practices. The *Inuvialuit Living History* project not only enables the interaction of originating communities and heritage collection, but, more importantly, it "represents an opportunity for originating communities to re-contextualize their cultural heritage in museums in new digital forms, potentially shifting power over representation from institution to Aboriginal publics." It is "a tool for Aboriginal self-representation and reclamation of ethnographic authority."

The volume closes with a conclusion. After reaffirming Nelson Goodman's claim that museums ought to advance understanding in the sense of forming, re-forming, or transforming vision, Chiel van den Akker concludes that digital technology should enhance and extend the museum experience and function rather than replacing them with something else. One consequence of this is that we should think of digital technology in terms of *means* rather than in terms of goals. If this conclusion is correct, then we know in a general sense what museums and their on-site and online visitors may gain by using digital technology. Each chapter in this volume affords some concrete examples of such benefits, without losing sight of the possible pitfalls accompanying the implementation of this new technology.

Acknowledgments

The editors' initiative for this collection of essays originates in the CATCH-Agora project, funded by NWO (The Netherlands Organisation for Scientific Research), grant 640.004.801.

1 Touched from a Distance

The Practice of Affective Browsing

Martijn Stevens

In the late nineteenth century, the fabulously rich industrialist Henry Tate, who had accumulated an enormous fortune by taking out a patent on sugar cubes, financed the construction of an art gallery near the River Thames in London. By the beginning of the twenty-first century, Tate Gallery had grown into a group of four museums with a sizeable collection that embraced painting, drawing, sculpture, prints, photography, film, and installation and performance, ranging from early modern British art to contemporary works by internationally celebrated artists. In 2002 Susan Collins put forward a sensational plan to add another exhibition space to the Tate Group. Details of the artist's proposal were revealed by Sandy Nairne, who was then in charge of a large-scale reorganization of the existing galleries:

> The next Tate site should be in space. At this stage a number of practical aspects of the project are being tested and an early pre-opening programme is being taken forward. This will clearly continue the Tate tradition of innovation and exploration, and provide a radical new location for the display of the collection and for educational projects.[1]

Several years before, a former power station on the far side of the river had been renovated and brought into use for the permanent display of Tate's international collection of modern art, while the original gallery from 1897 was restored to function as the national gallery of British art. Collins wanted to lift the plans for the expansion of the Tate to an even higher level by establishing an additional museum in a satellite orbiting the Earth at a distance of approximately 400 kilometers that would also serve as a temporary workplace for artists. She created a website with relevant information on the ambitious project including comprehensive essays, details on the course of the satellite, an overview of vacancies for the new location, and a discussion forum to facilitate the exchange of ideas among scientists, architects, artists, and other interested parties on the possible uses of an art gallery in deep space. Furthermore, several building plans

1 *Tate in Space*, http://www2.tate.org.uk/space/. Last accessed 9 January 2014.

for the exhibition space were available online as scale models that could be downloaded, printed, and folded into miniature versions of the satellite.

The website was a huge success, but it turned out to be a commissioned work of Internet art instead of a genuine platform for audience involvement in developing a new space program. The satellite would actually never be launched, and the chart of the supposed course was completely fictitious. The images of the direct video connection were in fact recordings of a colored bouncy ball on the dining room table at the artist's home. Collins later explained that she eventually had to "slow the whole thing down to make it more authentic and deliberately put in fuzz every so often so that people would really feel that it's having difficulty connecting."[2] The art project had nevertheless clearly fired the audience's imagination since reported sightings of the satellite kept coming in. Many people were apparently swept away by the prospect of a museum in the expansive universe, which demonstrates that the website

> also works as interactive or immersive fiction, where each visitor is encouraged to engage with their own extra-terrestrial cultural fantasies. Some aspects of the work – such as the satellite sightings data – rely on participants 'wishing' or 'believing' the narrative into existence ... And people pick up on it, their own imagination suddenly runs with the idea of what this new Tate might be.[3]

Collins's proposal might easily be understood as a piece of conceptual art that challenged the audience to rethink the very concept of the museum, but the project was actually not so much about the idea of expanding the Tate Group into outer space. The title of the artwork – *Tate in Space* – rather hinted at exploring the virgin territory of cyberspace, thereby touching upon a topical issue in the world of museums and heritage institutions. After all, at the turn of the millennium, many organizations were still trying to find their way in the virtual realm of the Internet in order to present their collections online. Merely concentrating on the means rather than the end, however, many institutions seemed to be neglecting the epistemological shifts that resulted from the digitization of museum and

2 S. Collins, "Tate in Space," in *DShed. Watershed's Showcase of Creative Work, Talks, Commissions, Innovation, Artist Journals, Festival Fiaries & Archive Projects.* Transcription of a conversation between Susan Collins and Jemima Rellie at Tate Modern on 20 February 2004. http://www.dshed.net/sites/digest/04/content/week2/tate_in_space.html. Last accessed 9 January 2014.
3 Collins, "Tate in Space."

heritage collections. Both the idea of the institution and the understanding of cultural heritage were nonetheless deeply affected by the process of digitization. This chapter will therefore elaborate on the new opportunities for the creation of meaning in a digital culture that are called into being by the online presentation of museum collections.

Responding to Change

The teasing subtitle of a critical review of Collins's project in a magazine for science and technology playfully referred to the challenges that came with the process of digitization: "Boldly going where no gallery has gone before."[4] Despite the mildly ironic undertone of the commentary, it may certainly be true that even today – more than a decade after the artwork was commissioned – the museums and heritage industry is still struggling to keep up with the rapid advance of ever new technologies. In early 2011, for example, the members of a so-called *Comité des Sages* who were invited by the European Commission "to provide a set of recommendations for the digitization, online accessibility and preservation of Europe's cultural heritage in the digital age" warned against the dawn of a digital Dark Age as the inevitable result of simply waiting and hence remaining inactive rather than taking full advantage of "the potential of bringing Europe's cultural heritage online."[5] In a similar vein, the American Association of Museums has established a research center to explore the future of museums and heritage institutions. Arguing that it would be careless to assume that someone else will struggle with the consequences of digitization, the founding director has advanced the thesis that organizations are required to counter the challenges of today's digital society so as to benefit from the emerging structural shifts as well as to avoid the harms of inaction.[6] While also emphasizing that digitization is no longer simply a matter of choice, a business report from the Dutch ABN AMRO Bank on digital strategies for art museums struck a somewhat lighter chord by focusing particularly on the social and economic benefits of using digital technologies in order to establish new connections between collections, exhibitions, activities, and

4 J. Kahn, "Art in Orbit. Boldly going where no gallery has gone before" *DISCOVER Magazine. Science, Technology, and The Future*, September Issue 2003.

5 E. Niggemann, J. De Decker and M. Lévy, *The New Renaissance: Report of the "Comité des Sages"* (Brussels: European Commission, 2003), 8.

6 E. Merritt, *Museums & Society 2034: Trends and Potential Futures* (The Center For the Future of Museums, 2008), 20.

audiences. John Stack, on the other hand, who is currently responsible for Tate's digital strategy, goes even further by bluntly stating that

> new technologies and online services, together with the proliferation of high-speed internet connections and mobile internet connectivity, have changed the web radically in the past few years. However, cultural and heritage organisations have been slow, by and large, to respond to these changes.[7]

Strongly believing that the process of digitization has penetrated to the core of everyday life in today's networked society, Stack argues that a digital mind-set evidently also needs "to become a dimension of everything that Tate does" – from the use of blogs and social media to ticketing, fundraising, and governance.[8] Such a holistic approach seems far removed from Tate's original policy to consider the website explicitly as a self-supporting and autonomous entity within the Tate Group.

Launched in 1998, Tate Online was primarily conceived as a concise catalogue of the museum's vast collection of paintings, sculptures, and sketches, but the website rapidly grew into a successful branch of the Tate Group that yearly received about twenty million unique visitors. Although the collection was still at the heart of the website, Tate Online gradually came to also include extensive modules for teaching and research, a large archive with audiovisual material, an award-winning application for visually impaired visitors, an online magazine, and a shop that offered customized replicas of original artworks as well as objects that were especially designed by renowned artists on the occasion of temporary exhibitions. Added to the acquisition of sponsorships, the sales of images to commercial parties, the joint income of four museum shops, the offering of catering services, and the profits of Tate's publishing house, the online activities generated an annual turnover of several million pounds, which were mostly ploughed back into the collection. They were nonetheless seen as disconnected from the core business of the museum until the spring of 2010 when Tate's online strategy for the next five years was presented to the trustees of the institution. The main ambition of the new plans was to move on from considering Tate Online as a separate part of the organization to integrating the digital, quite simply, into all of Tate's activities – both online and offline.

7 J. Stack, "Tate Online Strategy 2010-12," *Tate Papers* 13 (2010).
8 Stack, "Tate Online."

The proposed direction for the future indicated a fundamental shift in the view towards the position of digital technologies within the Tate Group. It necessarily involved radically different working methods, new modes of thought, and, as a consequence, a critical reassessment of the museum as a site for the production and dissemination of knowledge. After all, by introducing new means of documenting, ordering, and framing the various collections, Tate's holistic approach to digitization would undeniably lead to novel ways of interpreting and understanding artworks and historical artefacts, thus also changing the epistemological function of the museum.

Networked Knowledge

A closer look at the presentation of the collection on the Tate website is helpful to elucidate how digitization challenges the museum's established role in shaping a particular body of knowledge. Each work in the collection has an information page within a database that is accessible via the button "Art & artists" on the homepage, containing a digitized image and technical information such as title, artist's name, measurements, accession number, material, and year of acquisition. The list is further completed with links to the artist's biography, a summary of the work, related objects in the collection, and a set of keywords that are grouped in a thesaurus. The painting *The Billiard Players*, for example, is associated with the entry *billiards*, which in turn is part of the category *recreational activities* under the lemma *leisure and pastimes*. All keywords in the database are grouped accordingly in a tree diagram with countless bifurcations, thereby offering various possibilities to enter into the collection. Artworks can also be found by typing a query into the search field or doing a refined search by selecting a style or "-ism," date range, subject matter or type of object, thus enabling a visitor of the website to view all paintings currently on display at Tate Britain by Thomas Gainsborough and depicting a grasshopper or a scene at Berkeley Square in London. The results are then optionally sorted by title, reference number, artist or owner, date (oldest or most recent first), and number of views.

Despite being semantically rich, the businesslike inventory of the items in Tate's collection in terms of names, dates, and materials does not reveal anything about their perceived meaning or value.[9] Removed from galleries in brick-and-mortar institutions and stripped of their physical or tangible

9 B. De Baere and D. Roelstraete, "Mentaal Onderhoud". Bart De Baere en Dieter Roelstraete in Gesprek met Nico Dockx en Kris Delacourt," *AS Mediatijdschrift* 170 (2004), 101.

qualities, artworks appear on the Internet as virtual, hyperlinked objects with the fundamental properties or "crucial bits of art" essentially lost in the process.[10] The loss of substance is indeed often seen as a serious problem since preserving the original state of the physical objects in a collection is one of the main responsibilities of museums, archives, and libraries. Yet, in connection with the database of art on Tate's website, the question of substance is not simply a matter of "existing" in the sense of being physically present in a particular time and space. Because artworks are no longer necessarily material things that exist in three-dimensional space, the question is not simply to establish *that* they exist but rather *how* they exist or how they function within a given context.[11] After all, ever since the formation of the museum-as-institution, the interpretative framework for understanding a collection was determined by the spatial and temporal boundaries of the individual objects as well as the overarching structure of galleries and rooms, whereas the power of an online database consists in the possibility of establishing multiple connections between items that are historically and geographically far removed. Online presentations of museum collections are therefore to be considered as technologies of absent presence, which evidently has rigorous consequences for the creation of meaning.

The concept of absent presence is frequently used pejoratively with regard to the false impression of direct contact and "almost immediate presence" that is created by digital technologies.[12] According to Paul Virilio, one of the most-cited and best-known critics to have examined the effects of technological developments on contemporary society, the disappearance of tangible objects and their replacement by virtual substitutes that are only absently present amounts to a shift in experience towards being "telepresent" and reaching or feeling at a distance.[13] As digitization allows objects to be simultaneously present and absent, sensible reality is said to be doubled into the concrete reality of existing *in situ* – here and now – and the virtual elsewhere of telepresence.[14] Consequently, in Virilio's opinion, "a

10 W. Januszczak, "Re: http://bit.ly/hquMLO The basic assumption here is wrong. You can't online texture, scale, heft, contact – the crucial bits of art," 2 February 2011, http://twitter.com/JANUSZCZAK/status/32737315264659456. Last accessed 24 December 2014.

11 A.R. Galloway and E. Thacker, *The Exploit: A Theory of Networks* (Minneapolis, MN: University of Minnesota Press, 2007), 36.

12 D. Chandler and R. Munday, *Dictionary of Media and Communication* (Oxford: Oxford University Press, 2011), s.p.

13 P. Virilio, "Speed and Information: Cyberspace Alarm!" *CTHEORY*, 27 August 1995.

14 Virilio, "Speed and Information."

stereo-reality of sorts threatens" which inevitably leads to a fundamental loss of orientation, thereby further unsettling "the perception of what reality is."[15]

A contemporary of Virilio's and equally renowned for critically discussing the rise of electronic media and the socio-cultural effects of the ever-increasing use of communication technologies, Jean Baudrillard's impact on the burgeoning field of new media theory during the 1990s has also been profound. He is perhaps best remembered for suggesting a complete disappearance of the real in a world of virtual reality and pure simulation, which clearly resonates with the work of Virilio. Baudrillard's observations similarly end in an inescapable conclusion with regard to the experience of reality:

> When the real is no longer what it used to be, nostalgia assumes its full meaning. There is a proliferation of myths of origin and signs of reality; of second-hand truth, objectivity and authenticity. There is an escalation of the true … where the object and substance have disappeared.[16]

Having dominated the discourse surrounding digitization since the popularization of the Internet in the early 1990s, when virtual images of art works were first believed to "somehow compete with or detract from actual objects," the anxieties about loss and disappearance that were already voiced strongly by Virilio and Baudrillard more than two decades ago still reverberate in today's discussions surrounding the digitization of museum collections.[17] In view of the alleged disruption of settled practices in heritage institutions, the main reasons for concern include "a loss of aura and institutional authority, the loss of the ability to distinguish between the real and the copy, the death of the object, and a reduction of knowledge to information."[18] The opposing viewpoints in the debate – digitization is either a threat to museums or an opportunity to reinvent themselves – correspond with a dichotomy between virtual reality and "real" reality that is hardly ever questioned and is perhaps even unequivocally accepted. Nevertheless, since the beginning of the twenty-first century, scholarly work within both

15 Virilio, "Speed and Information."

16 J. Baudrillard, *Simulations* (New York: Semiotext[e], 1983), 12.

17 B. Graham and S. Cook, *Rethinking Curating: Art after New Media* (Cambridge, MA: MIT Press, 2010), 187, n12.

18 A. Witcomb, "The Materiality of Virtual Technologies: A New Approach to Thinking about the Impact of Multimedia in Museums" in *Theorizing Digital Cultural Heritage: A Critical Discourse*, eds. F. Cameron and S. Kenderdine (Cambridge, MA: MIT Press, 2010): 38-48 (35).

the humanities and the social sciences has witnessed an impelling motive to think against or beyond dualisms that are always necessarily (yet often implicitly) "structured by a negative relation between terms."[19] Notions of "negative relationality" are indeed widespread in mainstream cultural and media theory, which includes the work of Virilio and Baudrillard.[20] Underpinning the concept of telepresence and the corresponding possibility of being absently present, for example, is a binary opposition between a material, palpable, or real world and the supposedly intangible, disem-bodied, and abstract nature of digital environments. As a consequence, definitions of virtual reality are routinely grounded in the supposition that "the actual physical reality is disregarded, dismissed, abandoned."[21] The supposed discrepancy between both realms thus hence leads to a move "beyond and outside the body and its perceptual ... or material limits in the mode of action-at-a-distance," thereby negating the interrelatedness of "the very real effects of virtuality and the virtual dimensions of reality."[22] However, rather than simply entailing a displacement from the physical to the immaterial, the ongoing and unstoppable process of digitization has demonstrated the need to complicate and rethink traditional notions "to accommodate what they seem to oppose."[23] Besides being merely the absolute opposite of actual reality, the concept of virtuality is also "the domain of latency or potentiality," which allows for a shift to affective and affirmative forms of relationality that perhaps also counterbalances the implicit or implied hierarchy between both terms.[24]

Continuing this line of thought, I specifically seek to rematerialize the virtual by aligning myself with Laura Marks, who likewise critiques "the assumption that what is virtual must be immaterial, transcendent" rather than "interconnected in many ways."[25] Furthermore, she employs the notion of "optic visuality" to conceptualize the habit of seeing objects as "distinct, distant, and identifiable, existing in illusionary three-dimensional space."[26]

19 R. Dolphijn and I. van der Tuin, *New Materialism: Interviews & Cartographies* (Ann Arbor, MI: Open Humanities Press, 2012), 86.

20 Dolphijn and Van der Tuin, *New Materialism*, 122.

21 L. Manovich, *The Language of New Media* (Cambridge, MA: MIT Press, 2001), 113.

22 E. Grosz, *Architecture from the Outside: Essays on Virtual and Real Space* (Cambridge, MA: MIT Press, 2001), 81, 84.

23 Grosz, *Architecture from the Outside*, 86.

24 Grosz, *Architecture from the Outside*, 86.

25 L.U. Marks, Touch: *Sensuous Theory and Multisensory Media* (Minneapolis, MN: University of Minnesota Press, 2002), 178.

26 L.U. Marks, "Haptic Visuality: Touching with the Eyes," *Framework: A Finnish Art Review* 2 (November Issue 2004).

Introduced in Western thought with the invention of linear perspective in Renaissance painting and recently "refitted as a virtual epistemology for the digital age," the notion of optic visuality presupposes "a form of representation that requires distance" and an understanding of vision as "disembodied and adequated with knowledge itself."[27] Haptic visuality, on the other hand, allows for a view on cultural heritage that acknowledges the materiality of digital objects by sustaining "a robust flow between sensuous closeness and symbolic distance."[28]

Contrary to the well-worn belief that absent presence will eventually cause a loss of a sense of reality, the notion of haptic vision suggests that getting in touch from a distance is not simply geared towards overcoming barriers in time and space. It rather hints at the experience of proximity in terms of affinity, connectivity, and attraction, which is not necessarily dependent on the material presence of an object. Haptic looking seems therefore particularly suited to the display of museum collections on the Internet, which is obviously

a virtual reflection of the real world, but one that both mimics and is clearly different from the real spaces it reflects. The Internet is less a series of objects and spaces than a series of movements between them. This movement can be in 'logical' linear sequence … or it can take new pathways linked only by the random thoughts of the surfer, in that the surfer rides the movement.[29]

The concept of haptic visuality refers precisely to "a labile, plastic sort of look, more inclined to move than to focus."[30] Putting the surfer's personal preferences, expectations, and prior knowledge first, it favors the intuitive or affective browsing through digitized collections, whereby the various aspects of an object – color, material, year, theme – function as a link or a passageway to a diversity of associated objects, people, and events. Instead of using a list of factual data to denote and singularize a work of art that actually exists in time and space, haptic vision prefers connectivity and interrelatedness to the presumed uniqueness of a particular object. On the website of Tate, for example, the subject of boredom is used to describe *The Dining Room (Francis Place)*, a photograph from 1997 by Sarah Jones that

27 Marks, *Touch*, xiii.
28 Marks, *Touch*, xiii.
29 D. Sutton and D. Martin-Jones, *Deleuze Reframed* (London: I.B. Tauris, 2008), 30.
30 Marks, *Touch*, 8.

shows three girls at a dining room table. Besides characterizing a discrete work of art, however, the theme of the picture also functions as a pathway to other works in the collection, such as Edward Francis Burney's *Amateurs of Tye-Wig Music (Musicians of the Old School)*. The nineteenth-century painting depicts a group of musicians with the purpose of satirizing the conflicting attitudes of the day toward traditional and modern music. Through the person of George Frideric Handel, the oil painting is subsequently linked with a woodcut made in 2000 by Thomas Kilpper, who used a chainsaw and chisels to carve a portrait of the German composer into the mahogany parquet on the tenth floor of an abandoned building in London. The use of powerful, contrasting, and unnatural colors in Kilpper's work is also a distinctive feature of *Get Well Soon* by the recently deceased Craigie Aitchison, an abstract composition from 1969 that is screen-printed on paper in a lurid pink.

With the specific qualities of an object functioning as stepping stones to move between artworks from different centuries that are executed in various media, the act of clicking spontaneously or randomly through the collection database of Tate reveals unexpected and surprising correlations between objects that are normally not grouped together. Moreover, as the nature of the worldwide web is flexible and unstable, the connections between the different items in the database are constantly being made and unmade, thus incessantly giving new coherence to the collection and, consequently, offering new insights in objects, images, or documents that have become familiar over time.

Being Digital

Haptic vision and affective surfing appreciate the so-called "connective materialism" of Tate and thereby countenance the production of networked knowledge.[31] They are the threshold of a truly virtual museum, whereby the virtual is understood as

> the space of emergence of the new, the unthought, the unrealized, which at every moment loads the presence of the present with supplementarity, redoubling a world through parallel universes, universes that might have been.[32]

31 See also Marks, *Touch*, xi.
32 Grosz, *Architecture from the Outside*, 78.

Equally important as rematerializing the virtual, however, is a reassessment of the concept of the digital in relation to museums and heritage institutions. After all, in the same manner that cyberspace is not merely immaterial and discrete, "being digital" does not simply correspond with the physical presence of computers in the gallery space, the presentation of collections online, or the gradual incorporation of specific tools and applications such as collection management software into the daily routine of museum professionals. Rather, going far beyond "either discrete data or the machines that use such data," yet nonetheless entwined with software programs, electronic networks, or any other similar technology, the notion of the digital primarily "defines and encompasses ways of thinking and doing that are embodied within that technology."[33]

The logic of digitization is actually deeply rooted in social and cultural forces, which have been at least as important in shaping contemporary society – including museums, archives and libraries – as techno-scientific developments. It could even be argued that digital technologies are, possibly more than anything else, palpable expressions of "the social forms capable of producing them and making use of them."[34] They are, in other words, concrete manifestations of an underlying and already present digital culture that is characterized by modulation, distribution, and flexibility.[35] As a result, museums are currently in the midst of a so-called "epistemic break" between different ways of seeing and thinking, which poses a severe challenge for the production of institutional knowledge as well as the dissemination of specialist information to non-professional visitors.

An Epistemic Break

Indicating the fundamental shifts to new systems of knowing throughout history, epistemic breaks are basically tantamount to "the fact that within the space of a few years a culture sometimes ceases to think as it had been thinking up till then and begins to think other things in a new way."[36] The process of digitization has precisely caused a rupture in the museum and heritage sector, since discourses and institutional practices are now

33 C. Gere, *Digital Culture* (London: Reaktion Books, 2002), 11, 13.
34 G. Deleuze, *Negotiations 1972-1990* (New York: Columbia University Press, 1995), 180.
35 Galloway and Thacker, *The Exploit*, 31.
36 M. Foucault, *The Order of Things: An Archaeology of the Human Sciences* (London: Routledge, 2004), 56.

circulated "across distances with speeds unprecedented in world history" after having long changed and spread only gradually.[37] Concurrently, as digital technologies are becoming ever more pervasive in reshaping the social and cultural landscape of the twenty-first century, the ontology of the computer is projected onto the whole of society, and new metaphors or similes force themselves into play. Having already thoroughly restructured the discourses around human perception, memory, identity, history, politics, and ideology, the logic of digital networks and computerized databases is ineluctably also taking root in the field of museum and heritage studies.[38] Within many institutions, centralized forms of control are increasingly being affected by a flexible, dynamic, and networked view on power relations that is often both ideologically and architecturally placed in opposition to supposedly "retrograde structures like hierarchy and verticality."[39] Although the lively glance of haptic visuality appears to be more appropriate for digitized objects on a website than a contemplating or penetrating gaze, the history of collection display is nonetheless inextricably bound up with "the mastering, optical visuality that vision is more commonly understood to be."[40] After all, a museum collection is traditionally subdivided into partial collections that are subsequently displayed in separate rooms that are "neutralized by efforts to range and classify."[41] While internally coherent,

> each room is also insistently tied to the one before and the one after, organized through an obvious and apparent sequentiality. One proceeds ... from space to space along a processional path that ties each of these spaces together, a sort of narrative trajectory with each room the place of a separate chapter, but all of them articulating the unfolding of the master plot.[42]

Moving from room to room along a prescribed route, the audience quite literally enacts or performs the temporal span of art history, the evolution of life on planet Earth, or a similarly linear process of gradual origination, transformation, and development. The creation of meaning is thus strongly

37 J. McKenzie, *Perform or Else: From Discipline to Performance* (London: Routledge, 2001), 186.
38 See also C. B. Farrell. s.a. "Réaction programmée," *Art Mûr,* http://artmur.com/en/artists/ lois-andison/reaction-programmee. Last accessed 9 January 2014.
39 Galloway and Thacker, *The Exploit,* 25.
40 Marks, *Touch,* xvii.
41 R.E. Krauss, "Postmodernism's Museum without Walls," in *Thinking about Exhibitions,* eds. R. Greenberg, B. W. Ferguson, and S. Nairne (London: Routledge, 1996), 340-348 (342).
42 Krauss, "Postmodernism's Museum," 343.

associated with the setting and the architectural features of the museum building as well as the layout of the exhibition, the spatial arrangement of the objects on display, and the methods for guiding or directing the movements of visitors within the gallery.[43] By contrast, refusing to create a sequential and hierarchical ordering of a collection, a computerized database simply "represents the world as a list of items."[44] Furthermore, instead of drawing on the objects in a collection to narrate compelling and carefully edited stories, databases

> do not tell stories; they do not have a beginning or end; in fact, they do not have any development, thematically, formally, or otherwise that would organize their elements into a sequence. Instead, they are collections of individual items, with every item possessing the same significance as any other.[45]

As Tate's website clearly demonstrates, the cultural logic of the database allows for the incessant recombination of artworks and historical objects without necessarily systematizing a collection into a linear and unambiguous story or otherwise giving "meaningful coherence to ... discontinuous elements."[46] On the contrary, digital databases offer an image of the world that is highly structured yet "intensive, zigzagging, cyclical and messy."[47] They foster the re-conceptualization of heritage collections as flexible networks with multiple entry points and innumerable connections, thereby simultaneously introducing time-based procedures into the spatial organization of museum collections:

> The traditional archive becomes deconstructed by the implications of digital techniques. Since antiquity and the Renaissance, mnemotechnical storage has linked memory to space. But nowadays the static residential archive as permanent storage is being replaced by dynamic temporal storage, the time-based archive as a topological place of permanent data transfer. Critically the archive transforms from storage space to storage time.[48]

43 S. Moser, "The Devil is in the Detail: Museum Displays and the Creation of Knowledge," *Museum Anthropology* 33 no. 2 (2010): 22-32 (24).

44 Manovich, *The Language of New Media*, 225.

45 Manovich, *The Language of New Media*, 218.

46 W. Ernst, "The Archive as Metaphor: From Archival Space to Archival Time," *Open* 7 (2004): 46-53 (48).

47 R. Braidotti, *Transpositions: On Nomadic Ethics* (Cambridge: Polity, 2006), 167.

48 Ernst, "The Archive as Metaphor," 50.

Although digital databases in themselves may indeed be "essentially a fairly dull affair, consisting of discrete units that are not necessarily meaningful," they do not necessarily neglect the sensuous aspects of an artwork or the effects of an object's physical presence in a gallery space.[49] Seemingly meaningless details designate specific qualities that relate an object to a variety of other objects, thus opening up "a space of affinity and correlation of elements."[50] Moreover, corresponding to haptic visuality and providing the means for unexpected couplings, the cultural logic of the database allows for a move away from accustomed practices of looking that are informed by the dichotomy between material reality and the space of the virtual.

Zero Gravity

As critical museum studies have shown, the dissemination of knowledge through exhibitions is a fundamentally interpretative act that clearly involves a variety of choices – either explicitly or implicitly – with regard to the information panels, the lighting, the spatial arrangement of the objects, the captions, the furniture, the press handouts, the catalogue, etc. The digital presentation of museum collections entails yet another set of choices that constitute "different possibilities of knowing" and therefore a new "epistemological context."[51]

As a result of the switch from analogue to digital, the twenty-first-century museum is indeed assuming a novel role or shape to the same extent as the space of knowledge in the seventeenth and eighteenth centuries was "arranged in a totally different way from that systematized in the nineteenth century."[52] Museum websites and digital archives add new dimensions to accustomed practices of looking, as the representation of a coherent story, a central theme, or a particular history is knitted together with exploring unknown dimensions and tracing hidden connections within a collection. As up until now primarily taking place online and therefore extending far beyond the museum-as-institution, the practice of "looking digitally" and "feeling at a distance" is nonetheless also changing the epistemological significance of collection display in brick-and-mortar galleries. From the

49 C. Paul, *Digital Art* (London: Thames and Hudson, 2003), 178.

50 Braidotti, *Transpositions*, 170.

51 E. Hooper-Greenhill, *Museums and the Shaping of Knowledge* (London: Routledge, 1992), 191.

52 Foucault, *The Order of Things*, xi.

autumn of 2005 until recently, Tate Britain in London offered a glimpse of connective materialism within the walls of a traditional museum. The collection display in most rooms still featured a selection of artworks that were "arranged in a broad chronological sweep from 1500 to the present," but the playful project "Your Collection" encouraged visitors to traverse the linear course of history along a series of alternative routes. Consisting of fifteen walks that ran crisscross through the gallery, the project appealed to audiences with a variety of moods and tastes. Each walk included an illustrated map with a brief introduction and light-hearted descriptions to accompany a limited selection of artworks, such as a painting by Philip James De Loutherbourg. After having been temporarily available at the information desk near the entrance of the gallery, the leaflets were down-loadable from the museum's website.

Showing the first two of the four horsemen of the Apocalypse on a red and white horse, De Loutherbourg's *The Vision of the White Horse* 1798 (see figure 1) was originally designed for an illustrated Bible. The display caption at Tate Britain mentions that the depicted scene is characteristic of the last decade of the eighteenth century: "The French Revolution, the ensuing wars and the approaching millennium sparked a new trend for apocalyptic subjects. Artists explored themes of destruction and divine judgement and the end of mankind."[53] The painting was also incorporated in an alternative route called "The I'm An Animal Freak Collection" that offered a zoological journey through Tate Britain by focusing solely on pictures of sheep, dogs, and other animals. The horses in the biblical painting by De Loutherbourg were thus presented in a completely different context: "Now for some real horse power. What trusty steeds they are. If only we all owned a trusty steed instead of nasty polluting motor cars, the world would be a nicer place."[54] The pre-described walks of "Your Collection" further included "The Rainy Day Collection," "The I'm Hungover Collection," "The I Like Yellow Collection," and "The I've Just Split Up Collection," but the audience was also offered the possibility of curating a personal compilation of artworks by using a blank key map. Completed selections, which contained a title and a personal story that linked the chosen works together, could be printed or shared via e-mail.

Tapping into the virtual space of untold stories and highlighting the affective qualities of the works on display, the project spurred the imagina-tion of individual visitors without neglecting the educational function of

53 http://www.tate.org.uk/art/artworks/de-loutherbourg-the-vision-of-the-white-horse-t01138. Last accessed 9 January 2014.
54 http://www.tate.org.uk/britain/yourcollection/animalfreak. This URL is no longer online.

Figure 1 Philip James De Loutherbourg. *The Vision of the White Horse* **1798**

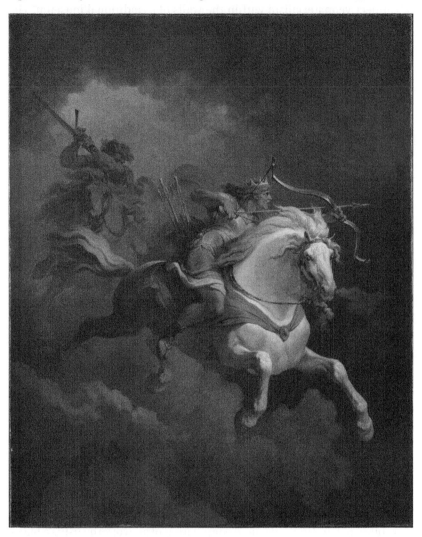

© 2015, Tate

the museum. After all, besides paying attention to the artist's intention
or the symbolic meaning of a specific painting, the audience was also
encouraged to concentrate on the ingenious composition of an artwork or
the intensity of the colors on the canvas. The counter-narratives of "Your
Collection" transformed the century-old institution of Tate Britain into a
space for intuitive or affective encounters with art in the same manner that
the website makes due allowance for a renewed view of the collection of

the Tate Group by abandoning chronology, medium, or subject as leading principles for ordering the collection. A reviewer for the *Evening Standard* conceded that the partial break with traditional discourses of art history and museum display was readily seen to be "the kind of gimmick that would make a serious art critic blanch and mutter about groupings of works that take no account of their different history or significance," yet the act of zigzagging through the gallery resulted in being "constantly surprised both by the familiar and the novel."[55] Not unlike *Tate in Space*, which encouraged the audience to engage with a work of imaginative storytelling, both the collection display at Tate Britain and the database logic of Tate's online presentation of art and artists keep opening up the affective space of virtuality by allowing for the unthought to be thinkable. Although the next phase in the history of museums is probably not heralded by travelling through outer space, the weightlessness of cyberspace and the infinite space of the virtual are equivalent to breaking loose from the gravitational pull that is exerted by traditional strategies of display.

55 N. Curtis, "Hangover? First Date? Split Up? Try Being an Art Bum. Tate Britain's New Set of Bespoke Tours Make It an Ideal Destination – No matter How You're Feeling," *The Evening Standard*, 21 September 2005, 35.

2 Visual Touch

Ekphrasis and Interactive Art Installations

Cecilia Lindhé

> An investigation of ekphrasis in this sense also reveals some of the energies that
> dwell within the texts that, to us, are black words lying still on the white page but
> which, to the ancient reader, were alive with rich visual and emotional effects.
> – Ruth Webb[1]

Visitors become part of the interactive installation *Text Rain* (1999) by
Camille Utterback and Romy Achituv as their silhouettes are projected
onto the screen and letters start to rain down on them. The letters stop
falling the moment they come in contact with their (projected) bodies,
but moving the body sets the letters in motion again. When the projected
participator has gathered enough letters, a word or even a phrase might be
formed. Thus "[r]eading the phrases in the *Text Rain* installation becomes
a physical as well as a cerebral endeavor," as Utterback and Achituv write.[2]
Jay Bolter and Diane Gromala, commenting on *Text Rain*, observe that:
"Visual art and design have never been pure, abstract, or removed from
the physical. For many designers, the senses of sight and touch always go
together, so that the world is seen and felt at the same time. This has been
true in earlier media, including print, and it remains true in new media."[3]
Text Rain explores this interaction between the physical and the virtual,
the body and technology, and reaffirms the fact that reading has always
been an embodied and multisensory experience.[4]

1 R. Webb, *Ekphrasis, Imagination and Persuasion in Ancient Rhetorical Theory and Practice*
(Farnham: Ashgate, 2009), 5.
2 http://camilleutterback.com/projects/text-rain/. Last accessed October 2015.
3 J.D. Bolter and D. Gromala, *Windows and Mirrors: Interaction Design, Digital Art, and the
Myth of Transparency* (Cambridge, MA: MIT Press, 2003), 122.
4 M. Hansen has written extensively about media installations and embodied meanings.
See Hansen, *New Philosophy for New Media* (Cambridge, MA: MIT Press, 2004); and *Bodies in
Code: Interfaces with Digital Media* (New York: Routledge, 2006). For a discussion on body and
embodiment, see also N. Hayles, *How We Became Posthuman: Virtual Bodies in Cybernetics,
Literature, and Informatics* (Chicago: University of Chicago Press, 1999).

A similar interaction between physical involvement and imagination arises in *Interactive Plant Growing*, developed by Laurent Mignonneau and Christa Sommerer. It was first shown at *Ars Electronica* in 1992 and some ten years later another version, *Eau de Jardin*, was developed for the House-of-Shiseido in Tokyo. The interface consisting of living plants sets up a connection between a user and a 3D rendering of virtual plants that are projected on a large screen. The living plants that send electronic signals to the corresponding and similar looking virtual 3D plants on a projection screen "interpret" the user's touch and movements. The user can manipulate the virtual plants to move in different directions by changing the distance between her hand and the living plant. She may for example rotate, twist, change, and develop new groupings of virtual plants, which creates complex and ongoing transformations that depend on the user's interaction.[5] The user's physical engagement with organic material has an immediate effect, thus constantly creating and re-creating the artwork.

This emphasis on tactility contradicts "the tactiloclasm" that permeates aesthetic theories that take works of art to be "untouchable" and are concerned with ocular scrutiny only.[6] How are we to account for artistic expressions that require spectators to participate in the work with both their body and mind? A fruitful way to think about this question is by examining the concept of *ekphrasis*. This concept addresses the special relation between descriptions and visual and emotional experiences, as the epigraph to this chapter asserts.

In what follows I will first elaborate on the concept of ekphrasis and focus on its origin in rhetoric and its defining features: orality, immediacy, vividness (*enargeia*), and tactility. This allows me to discuss the relevance of ekphrasis in connection to the interactive art installation *Screen*. By paying attention to rhetorical ekphrasis, I aim to bring out a digital ekphrasis in which the primary focus is not on the description of art and artefacts, but on the process of visualization. Ekphrasis, as it turns out, enables us to gain a better understanding of interactive installation art and our digital culture.

5 C. Sommerer and L. Mignonneau, "Cultural Interfaces: Interaction Revisited," in *Imagery in the 21st Century*, ed. O. Grau (Cambridge, MA: MIT Press, 2011), 201-218.

6 E. Huhtamo, "Twin-Touch-Test-Redux: Media Archaeological Approach to Art, Interactivity, and Tactility," in *MediaArtHistories*, ed. O. Grau (Cambridge, MA: MIT Press, 2008), 71-101. Huhtamo writes: "We could speak of 'tactiloclasms' – cases where physical touching is not only absent, but expressly prohibited and suppressed." 75.

Ekphrasis: Ancient and Modern

Ekphrasis is both a technical device and a literary genre. As a literary genre, ekphrasis is frequently used in Greek and Latin literature, at least since Homer. As a technical term within the study and practice of rhetoric, the origin of ekphrasis is documented in the first centuries AD where it occurs in the *progymnasmata*, which are exercises in compositional prose and rhetoric used in Hellenistic schools. The progymnasmata consists of four treatises attributed to Theon (first or fifth century), Hermogenes (second century), Aphthonios (fourth century) and Nikolaos (fifth century). Theon defines ekphrasis as "descriptive language, bringing what is portrayed clearly before the sight."[7] Hermogenes describes ekphrasis as an expression that brings about sight through sound: "Virtues (*aretai*) of an ecphrasis are, most of all, clarity (*saphêneia*) and vividness (*enargeia*); for the expression should almost create seeing through hearing."[8] Etymologically, ekphrasis stems from the Greek *ek* (out) *phrazein* (to explicate, declare) and meant originally "to tell in full." In her important *Ekphrasis, Imagination and Persuasion in Ancient Rhetorical Theory and Practice*, Ruth Webb defines ekphrasis thus: "Ekphrasis is a descriptive [*periēgēmatikos*] speech which brings (literally 'leads') the thing shown vividly (*enargōs*) before the eyes."[9]

The established definition of ekphrasis as "the verbal description of a visual representation"[10] is a rather modern modification of the ancient concept which, according to James Heffernan, "springs from the museum, the shrine where all poets worship in a secular age."[11] This type of ekphrasis is used to refer to printed words that describe visual works of art – a well-known ekphrastic poem, for example, is John Keats's "Ode on a Grecian Urn" 1820. I will hereafter call this type of ekphrasis the "modern ekphrasis."[12] Hewlett Koelb claims that "this new ecphrasis with its emphasis on obviously mediated subject matter is not just narrower but

7 *Progymnasmata: Greek Textbooks of Prose Composition and Rhetoric*, trans. and intro. G.A. Kennedy (Atlanta: Society of Biblical Literature, 2003), 45.

8 *Progymnasmata:* 86.

9 Webb, *Ekphrasis*, 51.

10 J. Heffernan, *Museum of Words: The Poetics of Ekphrasis from Homer to Ashbery* (Chicago: Chicago University Press, 1993), 3.

11 Heffernan, *Museum of Words*, 138.

12 Throughout this chapter I use Webb's distinction between the modern and ancient ekphrasis, see Webb, *Ekphrasis*. Several scholars have noted the modern tendency to associate ekphrasis with art only, see for example H. Maguire, *Art and Eloquence in Byzantium* (Princeton: Princeton University Press, 1981); and J. Hewlett Koelb, *The Poetics of Description: Imagined Places in European Literature* (New York: Palgrave Macmillan, 2006).

in its most basic character exactly the opposite of ancient Greek ekphrasis, whose aim is immediacy."[13] Indeed, the rhetorical practice of ekphrasis assumes a live audience and emphasizes immediacy and the impact of the ekphrasis on the listener. Webb summarizes the distinction between the rhetorical and the modern ekphrasis thus: "[I]n the ancient definition the referent is only of secondary importance; what matters ... is the impact on the listener."[14] Crucial for an effective ekphrasis was the underlying quality of enargeia, that is, vividness. An event or place is to be depicted so vividly that it comes to life in the listener's mind or eye.[15] The effect of enargeia is immediate and defers interpretation and assessment of the credibility of the evoked image to a later moment in time. The ancient ekphrasis not only includes vivid descriptions of works of art, as the modern ekphrasis does, but all vivid descriptions of artefacts, nature, events, situations, or persons.

Theorists who accept the modern definition of enargeia are often content with establishing that it is an effect that makes the reader envision what is being described. But enargeia does not first and foremost refer to a way of mimicking an object, scene, or person with words; it rather refers to the *effect* of seeing an object or event. It thus concerns the process of visualization.[16] The Roman rhetorician Quintilian states in his *Institutio Oratoria* at the end of the first century AD that it is not necessary for speech to contain enargeia markers (*evidentia,* in Latin) to be ekphrastic (for example, detailed descriptions and the use of symbols); what matters is the metamorphosis of the listener into a spectator.[17] He writes:

> It is a great gift to be able to set forth the facts on which we are speaking clearly and vividly. For oratory fails of its full effect, and does not assert itself as it should, if its appeal is merely to the hearing, and if the judge merely feels that the facts on which he has to give his decision are being narrated to him, and not displayed in their living truth to the eyes of the mind.[18]

13 Koelb, *The Poetics of Description*, 5.

14 Webb, *Ekphrasis*, 7.

15 Graham Zanker, "Enargeia in the Ancient Criticism of Poetry," *Rheinisches Museum* N. F. 124 (1981), 297-311. Quintilian, *Institutio Oratoria*, with an English translation by H. E. Butler (Cambridge, MA: Harvard University Press, 1953), 8.3.62.

16 Webb, *Ekphrasis*, 95.

17 Bernard F. Scholz, "'Sub Oculos Subiectio': Quintilian on *Ekphrasis* and *Enargeia*," in *Pictures into Words: Theoretical and Descriptive Approaches to Ekphrasis*, eds. Valerie Robillard and Els Jongeneel (Amsterdam: VU University Press, 1998), 73-99; Webb, *Ekphrasis*, 90.

18 Quintilian, *Institutio Oratoria*, 8.2.62.

As Webb has noted, Quintilian suggests that ekphrasis penetrates the listener more deeply, creating a distinction between words that stay, as it were, on the surface of the body, and those that penetrate it and reach the mind's eyes.[19] This distinction is also made in Greek sources. Nikolaos, for example, writes about the difference between descriptive speech and ekphrasis, where the latter "tries to make the hearers into spectators."[20] Quintilian describes language as close to a physical force affecting the listener's body.[21] He also writes about how visual impressions evoked by enargeia "make us seem not so much to narrate as to exhibit the actual scene while our emotions will be no less actively stirred than if we were present at the actual occurrence."[22]

Ekphrasis and enargeia are difficult to define independently from each other. To better understand these concepts, it is helpful to relate the concepts of enargeia and ekphrasis to the concept of *phantasia*. Phantasia denotes the orator's internal image that he communicates to the listener. In doing so he activates images that were latently stored in the listener's mind.[23] Interestingly, the orator should practice foreseeing what mental pictures would be required to make the ekphrasis vivid and thus successful. According to Webb, this creates a "simulacrum of perception itself. It is the *act of seeing* that is imitated, not the object itself, by the creation of a *phantasia* that is like the result of direct perception." Webb continues:

The ancient theory of *enargeia* thus sidesteps the problem of how to represent the visual through the non-visual medium of language because of the connection that is assumed between words and mental images. Words do not directly represent their subjects, but are attached to a mental representation of that subject.[24]

19 Webb, *Ekphrasis*, 98.
20 Nikolaos, *Progymnasmata*, ed. J. Felten (Leipzig: Teubner, 1913), 127.
21 Webb, *Ekphrasis*, 98. Webb writes about how Quintilian in his *Institutio Oratoria* compares the simple description of fact with the ekphrastic description and how differently they influence the listener on a physical plane: "The plain statement reaches only the ears while the vivid version, the equivalent of ekphrasis, 'displays the subject to the eyes of the mind.'" Webb, *Ekphrasis*, 98. On the same page, Webb furthermore emphasizes that "The Latin distinguishes between inner and outer senses of sight, where our Greek sources do not."
22 Quintilian, *Institutio Oratoria*, 6.2.32.
23 For a difference between poetic and rhetorical phantasia, see Quintilian, *Institutio Oratoria*, 6.2.29-32.
24 Webb, *Ekphrasis*, 128.

In the modern practice of ekphrasis, the focus is on the visual object referred to, whereas the ancient rhetoricians emphasized the process of visualization and the effect it had on the listener.[25] The significance of the body and the emphasis on bodily senses in the rhetorical situation were thus crucial.[26] Orality, immediacy, vividness, and tactility are all central to interactive media installations. I will substantiate this claim by analyzing the interactive installation *Screen*.

Screen

A visual setting where the images could be said to set in motion a variety of imaginative, emotional, and rational reactions, even before a voice starts to speak, characterizes the interactive installation *Screen* (2003).[27] *Screen* raises questions about memory, and it does so through the orchestration of an aesthetic that brings attention to oral, print, and digital communication strategies. The user can listen to words, read words, and touch words. Words are read out loud, they are displayed in temporal sequence on a page-like wall, but they also move around in a three-dimensional space. In an interview, Noah Wardrip Fruin comments on the difference between the stable, temporal, and printed text, and the fluidity of the digital text: "The word-by-word reading of peeling and striking, and the reading of the word flocks, creates new experiences of the same text – and changes the once normal, stable, page-like wall text into progressively-altered collages."[28] *Screen* is created and can be viewed in a CAVE environment, typically a room with four surfaces that includes three walls and a floor display. Text and graphics can be projected onto the walls as well as onto the floor. When the visitor enters the cave wearing goggles and gloves, a text is displayed on one of the walls as well as read out loud by a male speaker.

25 For example, ps.-Longinos is interested in the effect on the listener rather than in the ontological status of the subject of the visions. See Webb, *Ekphrasis*, 118.

26 This has also been emphasized by Mary Carruthers: "*Enargeia* addresses not just the eyes, but all the senses. It is easy to forget this when we read rhetoric texts, because the emphasis is so much on the visual sense. But the visual leads on to and is accompanied by an engagement of all the other senses in a meticulously crafted fiction." See M. Carruthers, *The Craft of Thought: Meditation, Rhetoric, and the Making of Images, 400-1200* (Cambridge: Cambridge University Press, 1998), 132.

27 By Noah Wardrip Fruin, together with Josh Carroll, Robert Coover, Shawn Greenlee, Andre McLain, and Benjamin Shine. *Screen* was first shown in 2003. A later version was made for *SIGGRAPH* in 2007.

28 http://www.dichtung-digital.de/2004/2/Wardrip-Fruin/index.htm Last accessed 15 June 2016.

In a world of illusions, we hold ourselves in place by memories. Though they may be but dreams of a dream, they seem at times more there than the there we daily inhabit, fixed and meaningful texts in the indecipherable flux of the world's words, so vivid at times that we feel we can almost reach out and touch them. But memories have a way of coming apart on us, losing their certainty, and when they start to peel away, we do what we can to push them, bit by bit, back in place, fearful of losing our very selves if we lose the stories of ourselves. But these are only minds that hold them, fragile data, softly banked. Increasingly, they rip apart, blur and tangle with one another, and swarm mockingly about us, threatening us with absence.[29]

This opening text is followed by three other short poetic descriptions of the oscillation between dreaming and being awake. The description of memories as being "so vivid at times that we feel we can almost reach out and touch them" may not only be interpreted as a description of enargeia: it is also literally enacted the moment the words start to peel away from the walls and float freely into the space surrounding the visitor. The visitor can try to put them back into place with the data glove, but that becomes increasingly difficult when the words are detaching themselves faster and faster. This could be compared to the description of ekphrasis as words being a force acting on a listener, which we discussed above. The immediacy of the experience is evident. Eventually, when too many words are floating around the visitor, the texts collapses. Finally, a male voice reads the following text aloud:

We stare into the white void of lost memories, a loose scatter about us of what fragments remain: no sense but nonsense to be found there. If memories define us, what defines us when they're gone? An unbearable prospect. We retrieve what we can and try again.[30]

As Roberto Simanowski points out, *Screen* raises questions about memory and place: "What ... defines memory. Is it what is stored in an external medium or what one carries around in the mind?"[31] The installation brings the close connection between visualization and memory to the fore by

29 http://collection.eliterature.org/2/works/wardrip-fruin_screen.html
30 http://collection.eliterature.org/2/works/wardrip-fruin_screen.html
31 R. Simanowski, *Digital Art and Meaning: Reading Kinetic Poetry, Text Machines, Mapping Art, and Interactive Installations* (Minneapolis: University of Minnesota Press, 2011), 46.

means of the visitor's bodily and imaginative interaction with the words
that peel off and are put back in place. The overlap with the ekphrastic
situation is striking. Webb: "The audience (whether readers, listeners,
viewers or spectators) combine a state of imaginative and emotional
involvement in the worlds represented with an awareness that these
worlds are not real."[32]

Without simply identifying the orator's situation and interactive instal-
lations, it is illuminating to bring to mind the orator's task to involve and
interact with the audience. As Webb writes: "To emphasize the rhetorical
nature of ekphrasis is also to draw attention to the vestigial orality of the
phenomenon, the way in which the discussions of both ekphrasis and
enargeia assume a live interaction between speaker and audience, with
language passing like an electrical charge between them."[33]

Ekphrasis, we saw, brings about sight through sound; it creates "seeing
through hearing," in the words of Hermogenes. The auditory dimension of
ekphrasis has been lost in the modern definition but was of course central
to the rhetorical situation and oral poetry. The male voice in *Screen* can be
seen as a guide showing his visitor around, giving her a tour. The spoken
words direct the visitor's attention towards the text, and the speaker leads
the visitor through the work. Ekphrasis as a descriptive speech "which
brings (literally 'leads') the thing shown vividly (*enargōs*) before the eyes"
also identifies the speaker with a guide who shows its audience around.[34]
Therefore Webb's description of the rhetorical situation as both a theater
and an exhibition is highly appropriate in the context of installation art:
"Drawn as they are from different domains, these metaphors all suggest
slightly different relationships between speaker, addressee and referent: the
subject matter may be 'brought' into the presence of the audience (speaker
as theatrical producer), or the audience may be 'led around' the subject
(speaker as tour guide)."[35]

32 Webb, *Ekphrasis*, 168-169.

33 Webb, *Ekphrasis*, 129.

34 Webb *Ekphrasis*, 51, 54. This could be compared to the rhetorical concept of ductus that:
"analyse the experience of artistic form as an ongoing, dynamic process rather than as the
examination of a static or completed object. *Ductus* is the way by which a work leads someone
through itself." See M. Carruthers, "The Concept of *Ductus*, Or Journeying through a Work of Art,
" in *Rhetoric Beyond Words: Delight and Persuasion in the Arts of the Middle Ages*, ed. Carruthers
(Cambridge: Cambridge University Press, 2010), 190-213 (190).

35 Webb, *Ekphrasis*, 54-55.

Conclusion: Digital Ekphrasis

Recently there has been a substantial critique of the hegemony of vision in our Western culture.[36] Indeed, sight has always been considered to be the noblest of senses. In *The Senses of Touch*, Mark Paterson shows how Greek geometry was multisensory and dependent on the body too. He writes:

> Before it becomes an abstracted, visual set of symbols on a surface, at one stage geometry involved the actual bodily process of measuring space. In the measuring process the hands, feet, eyes and body are all involved in spatial apprehension and perception. Spatial relations mediated through the body become represented in abstract form through a set of visual symbols. As we know, such visual symbols become part of a whole system of representation, geometry, which is subtracted from the original, embodied measuring process.[37]

The development of geometry into an abstract concept also meant an active forgetting of the senses which implies a move from "the variability of the senses and sensory experience to the static invariability of a desensualized, abstract space."[38] This development is, according to Paterson, symptomatic of how the body has been erased in Western history in favor of the visual sense. The development of geometry into an abstract concept provides an interesting parallel to the distinction we have made between ancient and modern ekphrasis. In the modern definition of ekphrasis, the description of a work of art too becomes part of a representational system, a literary genre, with the consequence that the embodied meaning is subtracted from the ancient term. *Text Rain, Interactive Plant Growing,* and *Screen* show that the body is vital to contemporary digital installations and digital ekphrasis – with its emphasis on orality, immediacy, vividness, and tactility, which, as we have seen, are all integral aspects of these artworks. As Simanowski

36 See for example M. Paterson, *The Sense of Touch: Haptics, Affects and Technologies* (Oxford: Berg, 2007); C. Classen, *Worlds of Senses: Exploring the Senses in History and Across Cultures* (London: Routledge, 1993); M. Jay, *Downcast Eyes: The Denigration of Vision in Twentieth-Century French Thought* (Berkeley: University of California Press, 1993); J. Crary, *Techniques of the Observer: On Vision and Modernity in the Nineteenth Century* (Cambridge, MA: MIT Press, 1990); and E. Huhtamo, "Shaken hands with statues...: On Art, Interactivity and Tactility," *Second Natures*, Faculty Exhibitions of the UCLA Design-Media Arts Department (Los Angeles: California University Press, 2006), 17-21.

37 Paterson, *The Senses of Touch,* 60.

38 Paterson, *The Senses of Touch,* 65.

writes: "Interactive art restores the intrinsic link of affect and the body: 'one is seeing with the body' ... and one is 'seeing through the hand.'"[39] It in other words conveys an aesthetic of tactility.

Ekphrasis is an overlooked concept in discussions about interactive installations. Some authors have even denied the usefulness of ekphrasis as a critical tool, but they are only able to argue their case if they make use of the modern concept of ekphrasis and disregard its ancient meaning.[40] As this chapter showed, it is fruitful to reinterpret the concept of rhetorical ekphrasis in the context of interactive installations. Orality, vividness, immediacy, and tactility direct us to the heart of both installation art and rhetoric, for as Mary Carruthers contends, "the heart of rhetoric, as of all art, lies in its performance: it proffers both visual spectacle and verbal dance to an audience which is not passive but an actor in the whole experience, like the chorus in drama."[41]

Rhetoric may serve as a conceptual foundation for digital installations, as for example the recently finished *Imitatio Marie* project about medieval material culture shows.[42] The combination of rhetoric and interaction technology suggests new modes of critique and a novel understanding of the ways in which our culture always finds itself in a continuous process of re-formulation, re-interpretation, and re-purposing of our cultural heritage.

Acknowledgements

This chapter uses some material from my "A Visual Sense is Born in the Fingertips," *Digital Humanities Quarterly* 7 no. 1 (2013).

39 Simanowski, *Digital Art and Meaning*, 125.

40 Ryan, *Narrative as Virtual Reality: Immersion and Interactivity in Literature and Electronic Media* (Baltimore: Johns Hopkins University Press, 2001), 60-61; O. Grau, *Virtual Art: From Illusion to Immersion* (Cambridge, MA: MIT Press, 2003), 15.

41 Carruthers, "Editor's Introduction," in *Rhetoric Beyond Words*, ed. Carruthers, 2.

42 C. Lindhé, A. Eriksson, J. Robertsson and M. Lindmark, "Curating Mary Digitally: Digital Methodologies and Representations of Medieval Material Culture" in *Research Methods for Creating and Curating Data in the Digital Humanities*, eds. M. Hayler and G. Griffin (Edinburgh: Edinburgh University Press, 2016). The interdisciplinary research project *Imitatio Mariae: The Virgin Mary as a Virtuous Model in Medieval Sweden* examined Swedish (representations of) the Virgin Mary in the late Middle Ages and their re-mediations in a digital environment. The project was affiliated with HUMlab, a digital humanities laboratory at Umeå University, Sweden, and financed by the Swedish Research Council. The installations we designed were based on the rhetorical concepts of memoria, ductus, and ekphrasis. The project ended in 2014. For the project's website, see https://imitatiomariae.wordpress.com. Last accessed October 2015. See also C. Lindhé, "Medieval Materiality through the Digital Lens," in *Between Humanities and the Digital*, eds. D. Goldberg and P. Svensson (Cambridge, MA: MIT Press, 2015), 193-204.

3 Breathing Art

Art as an Encompassing and Participatory Experience

Christina Grammatikopoulou

> Man is but a network of relationships, and these alone matter to him.
> – Maurice Merleau-Ponty

Protective glass, ropes, and "do not touch" signs – used in museums in order to prevent the artwork from being touched – seem out of place in contemporary art spaces where the experience of art stretches beyond the limits of ocular perception. The "final touch" to interactive art is given by the participant who explores the environment and interface designed by the artist through touching, listening, moving around, and breathing. In this artistic reality, established dichotomies such as "artist/public" and "artwork/spectator" no longer apply.

In this chapter I will examine four interactive artworks that are based on body movement and breathing. In order to understand how these works affect the perception of the world, I will follow a phenomenological approach that departs from research on breathing. Although I acknowledge the socio-political aspects of participation,[1] this chapter's focus is on the role of the body in interactive art and the way it alters perception. Before exploring the role of the public as co-creators of interactive artworks that require participation through the body, I will first introduce the relevance of a phenomenology of perception and breathing in this context.

From the Sanctified Art Object to the Ritual of Art Experience

Twentieth-century artists ceased to create "sanctified art objects" as they engaged in performance art and happenings and counted on interaction

1 On the socio-political aspects of participation, see C. Bishop, "Participation and Spectacle: Where are we now?" lecture for Creative Time's Living as Form, Cooper Union, New York, May 2011; and C. Grammatikopoulou, "Utopia and Realism in the Participatory Art of the Digital Era," in *Urban Conflicts*, ed. V. Makrygianni et al. (Thessaloniki: Sinantisis ke Sigrousis stin Poli, 2014), text in Greek, 203-214.

with the public. The public's role was not just to see and "worship" the art object; people had to become part of the "ritual" and the creative process of art making. Through participation, the experience of art unfolds within a broader life experience. Instead of maintaining a critical distance from the artworks, people are expected to intervene in them.

These new artworks faced a certain amount of skepticism from some critics. Theodor Adorno for example stated that "just as artworks cannot intervene, the subject cannot intervene in them; distance is the primary condition for any closeness to the content of works."[2] This concern was shared by Oliver Grau, who noted in relation to immersive art that it is "characterized by diminishing critical distance to what is shown and increasing emotional involvement in what is happening." He also worried that these open and ephemeral artworks could not become part of historical memory.[3]

The questions of memory and the role of museums in safeguarding it thus became crucial. Any display of audiovisual material related to the artwork, even the installation of the work itself, is mere documentation of the artistic process. The interactive artwork itself exists only for as long as the art event takes place, that is, as long as the people are engaged in it. Consequently, the traditional concept of the art museum as a gallery exhibiting paintings and sculpture no longer applies here: one would do better to think of the museum as a theater in which a participating public is central. As Lizzie Muller and Ernest Edmonds observe, there is "a general evolution in the concept of the museum from a repository of both objects and authority to a site of questioning and experience."[4]

In a sense, the original meaning of the museum (*mouseion*) as a place of artistic creation and worship of the arts is revived. The participation of the public in the process of creation "changes the relationship of the artist and curator to the public, and the relationship of the public to the artwork, creating a culture of participation and contribution rather than consumption."[5] Within this context, the museum or art space becomes a *laboratory* where the work of art is produced through the synergy of the artist, the public, and technology. Although this understanding of the museum can be traced back to Alfred Barr, who as early as 1939 envisioned the Museum of Modern Art as "a laboratory: in its experiments the public is

2 T.W. Adorno, *Aesthetic Theory* (London: Continuum, 2004), 293.
3 O. Grau, *Virtual Art: From Illusion to Immersion* (Cambridge, MA: MIT Press, 2003), 13, 207.
4 L. Muller and E.A. Edmonds, "Living Laboratories: Making and Curating Interactive Art," *SIGGRAPH 2006 Electronic Art and Animation Catalog* (New York: ACM Press, 2006), 147-150 (148).
5 Muller and Edmonds, "Living Laboratories," 149.

invited to participate,"[6] the materialization of this vision in contemporary art spaces requires us to acknowledge that these laboratories exist at the intersection of artistic and scientific research.

The artists discussed in this chapter pursue their scientific and scholarly inquiries through visual arts research. Char Davies, George Khut, Christa Sommerer, Laurent Mignonneau, and Thecla Schiphorst fuse technology with body movement and function in order to create a new language of communication – a language based primarily on experience, intuition, and feeling. In a way, they anticipate developments in computer technology that have a strong focus on the body and incorporate body movement into device operating systems. At the same time, by examining the reception of their artworks, we can see how the public adopts a new role in museums and art spaces, a role that is more playful, active, and open to communication.

Viewing the Body and the Mind as a Whole: a Phenomenological Approach

The body has become a center of experience in participatory art and the latest generation of information technology such as motion-tracking video games, smart phones, touch screens, and tablets. It entails a radical shift from the view that the body is a mere "tool" of the mind that receives stimuli through the eyes and other senses and gives orders to hands, fingers, and other body parts. This turn to experience and the body was preceded by certain developments in Continental philosophy.

For a long time philosophical thought flourished under the influence of Descartes, who separated the mind, a non-material entity, from the body, which is subject to the laws of nature, and who considered the mind to be superior to the body. Subsequently, Alexander Baumgarten, who conceived of aesthetics as a source of knowledge by means of the senses, made a distinction between "higher" senses that were tied to the mind ("seeing" and "hearing") and the senses tied to the "inferior" body ("smelling", "touching", and "tasting").[7] Bridging the gap between body and mind became one of the main foci of phenomenology, which aims to understand the human being in

6 A.H. Barr, "Art in Our Time," in *Art in Our Time: An Exhibition to Celebrate the Tenth Anniversary of the Museum of Modern Art and the Opening of its New Building, Held at the Time of the New York World's Fair* (New York: Ayer Publishing, 1939), 15.

7 A.D. Chaplin, "Art and Embodiment: Biological and Phenomenological Contributions to Understanding Beauty and the Aesthetic," in *Contemporary Aesthetics Journal* 3 no. 2 (2005).

its entirety. A decisive step in this direction was made in the philosophy of Edmund Husserl, who stated that, "I do not have the possibility of distancing myself from my body, nor it from me." One cannot observe the body as a separate entity because the body is part of the Self and it would take a second body to observe one's own. Even though in the beginning Husserl adopted a more "static" approach to analyzing consciousness, he later moved on to genetic and generative models of thought, explaining how experience evolves dynamically in time and how it is shaped in relation to the outside world.[8] The latter two ideas are of particular importance when discussing interactive art.

Husserl rejected Cartesianism but nevertheless maintained a distinction between consciousness and reality, mind and body, subject and object: "All sensings belong to my soul (*Seele*), everything extended to the material thing," he wrote.[9] By contrast, for Maurice Merleau-Ponty, "the body is not a transparent object" but rather "an expressive unity which we can learn to know only by actively taking it up." In other words "we are our body," and we experience the world through it: "The body is a natural self and, as it were, the subject of perception."[10] In this line of thought there is no distinction between subject and object, body and mind. Here the body is "the place where consciousness and reality ... come to occupy the very same conceptual space."[11] Perception is an active, bodily involvement with our surroundings. That is to say, one feels one's own body not as an "objective body," as a "thing," but as a "lived body" inseparable from one's mind and sensory experiences.

The movements and gestures of the body are from a Merleau-Pontian point of view one with the thoughts behind them. When we reach out our hand to pick up an object, thinking and reaching out are inseparable and form an integrated bodily performance. This is also true of artistic works whose existence cannot be separated from what they express, since they are the outcome of a gesture and hence the embodiment of the artist's intention. The tool of expression – the brushstrokes, for example – becomes integrated in their action, as if they were "thinking with the brush." Similarly, when

8 For further analysis of static and genetic phenomenology, see E. Thompson, *Mind in Life: Biology, Phenomenology, and the Sciences of the Mind* (Cambridge, MA: Harvard University Press, 2007), 28-30, 43; and A.J. Steinbock, "Husserl's Static and Genetic Phenomenology: Translator's Introduction in Two Essays," *Continental Philosophy Review* 31 (1998): 127-134.

9 Quoted in T. Carman, "The Body in Husserl and Merleau-Ponty," *Philosophical Topics* 27 no. 2 (1999): 205-225 (209).

10 M. Merleau-Ponty, *Phenomenology of Perception* (London: Routledge, 2005), 239.

11 Carman, "The Body in Husserl and Merleau-Ponty," 209.

the artistic means of expression is a sensory device, then the actions of the artist – or the public in case of interactive art – are defined and shaped by that tool; intention and outcome are thus conceived as a whole.

Subsequently, applying the phenomenological notion of perceiving through experience to the changes brought forth by information technology reveals how digital technologies shape our way of apprehending the world and cultural phenomena. At the same time, it strengthens the viewpoint that one can understand art better when involved in it rather than a passive observer of it. Interactive art can have an immediate effect on the people involved in the artistic experience. Therefore, maintaining a distance between the art object and the public as Adorno and Grau suggest is not central to art perception. In fact, bridging the gap between the two appears to be more effective.

For that reason, phenomenology is a suitable approach to theorizing the implications of using digital devices and interactive media that encompass the user. The Cartesian dualism between the controlling mind and the controlled object is dropped in favor of a more integral approach in which the whole body is brought into focus. Additionally, the separation between theory and cultural practice should be dropped as well. A more encompassing model of thought that views practice and theory as inseparable can be found in Eastern philosophical traditions. In Indian philosophy, for example, the relationship between body and mind is treated as dynamic and mutually interdependent, something that can be consciously changed through practice and meditation. Therefore, if we sought to view participatory art through a framework that involves both theory and practice, we could enrich the phenomenological approach with a consideration of the Indian philosophical traditions that view theory and practice as indistinguishable. The aim of these traditions is to train the body and mind in such a way that the practitioners experience their mind and body as one.[12] On a practical level, experiencing the unity of body and mind requires advanced meditational skills, which allow practitioners to disconnect themselves from outside stimuli and thoughts until there is nothing left to perceive but the rhythm of their own breath. The same effect can be achieved the other way around, by concentrating on one's own breath until the mind is cleared from exterior distractions and one begins to get a sense of oneself.

The breathing practices that are present in different religious and medical traditions around the world are based on the easily observable fact

12 For the significance of breath in Indian culture and performative practice, see S. Nair, *Restoration of Breath: Consciousness and Performance* (Amsterdam: Rodopi, 2007), 78-100.

that there is a correlation between our emotional state and our breathing rhythm. In these traditions, especially the ones originating in India, one can find detailed instructions on how to let the air enter the body and how to let it out. After following these practices for some time, one experiences the connection of body and mind and the connection of oneself to the world. This approach has certain similarities with phenomenology, but within a more practical frame. Expanding one's consciousness through such practices means that the sense of the "lived body" is enhanced.

Subsequently, phenomenological theory combined with traditional cultural practices could be used as a way to understand how participatory and interactive art can alter perception. Inviting viewers to participate in the artistic experience by means of their body and breathing can have effects similar to other cultural practices that enhance perception by means of controlling breath and body movements: "Breath is a potent tool of overcoming dualism,"[13] which could explain why the artists mentioned in this chapter use it as a prime element of creation as they seek to illustrate the indivisibility of body and mind. The artworks examined below use the body as an instrument for grasping the world,[14] putting into practice the phenomenological and breath-related theories we have just discussed.

Osmose: Going Beyond the Body/Mind Divide

From its first presentation in 1995 up to this day, Char Davies's *Osmose* has been reflected upon from numerous points of view such as phenomenology, aesthetics, and the theory of reception. The work was very innovative for its time because it created an environment where participants could feel fully immersed with both their body and their mind, which was very different from the paths then taken by virtual reality projects.

At the end of the twentieth century, the prevailing notion of virtual reality entailed a Cartesian space in which the mind was in charge and the body was simply a shell for the brain, receiving information through the eyes and ears and commanding hands to push buttons.[15] Davies rejected this notion categorically, believing that "it's important that we reaffirm

13 D. Leder, *The Absent Body* (Chicago: University of Chicago Press, 1990), 178.
14 G.P. Khut, "Development and Evaluation of Participant-Centred Biofeedback Artworks," (PhD diss., University of Western Sydney, 2006), 26.
15 C. Davies, "Landscape, Earth, Body, Being, Space, and Time in the Immersive Virtual Environments *Osmose and Ephémère*," in *Women, Art and Technology*, ed. J. Malloy (Cambridge, MA: MIT Press, 2003), 322-337 (326).

**Figure 2 Char Davies. Breathing and balance interface used in the performance of
immersive virtual reality environments** *Osmose* **(1995) and** *Ephémère* **(1998)**

© 1995, Char Davies

the body, reassert our materiality"[16] within virtual spaces. She created an environment in which users, or "immersants" as she called them, navigate with their body by leaning slightly or changing their breathing rhythm. Thus, there is no distance between the world and the person observing it, as there usually is with computational devices that are operated by a joystick or mouse. As Grau observes, "The more intensely a participant is involved, interactively and emotionally, in a virtual reality, the less the computer-generated world appears as a construction: Rather, it is construed as personal experience."[17] This principle foreshadows contemporary mobile devices and video games that track the user's movements and individual preferences.

As a first step to being "immersed" into the world of *Osmose*, visitors had to wear a head-mounted display and a motion-tracking vest (see figure 2). These devices transferred them into a virtual space where the navigable landscape, dominated by a tree, a pond, and columns with the code of the work, was balanced with subtle music; image, music, and code emerged as a new kind of poetry composing an encompassing environment. Moving within this space created a feeling of floating in water, which had been the prime source of inspiration for the artist, an experienced diver.

In order to control their journey, the immersants had to change their breathing rhythm, steady for a smooth journey and faster for a more rapid one, as well as their posture, leaning slightly towards one side or the other. This way, the artwork stimulated a two-way interaction between the body and the environment: on one hand, the body controlled the journey within the virtual landscape (see figure 3) through leaning and breathing; on the other hand, the images the immersants came across in their turn could have an impact on their emotional state, thus altering their breathing again and further changing the experience of their journey.

Osmose is revealed to the visitor as an inner space for self-reflection rather than a work of art to be admired from a distance. Users noted that they experienced the immersive space as "contemplative, meditative peace."[18] This is due largely to the use of breath and bodily movements as a means of navigation – on a par with Eastern meditation techniques based on breath and body balance; altering breathing rhythm and body movements in a conscious way can lead to a different state of mind.

16 M.J. Jones, "Char Davies: VR through Osmosis", *CyberStage* 2 no. 1 (1995): 24-28.
17 Grau, *Virtual Art*, 200.
18 Grau, *Virtual Art*, 199.

Figure 3 Char Davies. Forest Grid, *Osmose* (1995). Digital still captured in real-time through HMD (head-mounted display) during live performance of the immersive virtual environment *Osmose*

© 1995, Char Davies

Even the participants who had a feeling of panic at first were eventually soothed by the experience of the virtual journey: "I had vertigo when looking down ... After the initial panic, it was amazing and relaxing."[19] Such a reaction is normal for someone "crossing" a completely unknown space where the laws of nature do not apply; but as the body learns the "laws" of the virtual space and becomes familiar with the new environment through experience, the participant manages to relax. This procedure helps us to see how we learn and understand through experience on an everyday level.

The observations of the users about a feeling of being "gently cradled" and being put in a trance-like state have a very intimate character. At the same time, the overall reception of *Osmose* shows that the work is easily accessible to a broader public; as the visitors observe the backlit silhouette

19 Grau, *Virtual Art*, 199.

of the immersant along with the images of his or her journey through the virtual space, the work becomes a collective experience.[20]

Cardiomorphologies: a Colorful Reflection of the Inner Body

George Khut works within the same field as Davies and also tries to undo the separation of body and mind. His work uses biofeedback technology that measures bodily movements and functions, translating the collected data into sounds and images.

In *Cardiomorphologies v.2* (2005), visitors are invited to sit in a reclining chair where they have their pulse monitored through a handheld device and their breathing measured by a pressure-sensitive strap placed around the ribs (see figure 4). The collected data is analyzed into abstract colors and circles on a screen in front of them, while the sounds of their heartbeat and breathing are transmitted through headphones. As in *Osmose*, there is a two-way communication between the participant and the artwork: the images on the screen reflect the participant's mood, yet they can also have an impact on it. Participants can sit and observe the visuals or they can try to actively control them by changing their breathing and emotional state.

Khut designed *Cardiomorphologies v.2* while considering the participant's experience in each stage of the work's development. As he notes, "My goal through this process was to create a work that allowed participants to explore the embodied nature of their subjectivity through a detailed and sustained focus on their own breathing and heart rate patterns."[21] Khut is primarily concerned with helping the participants gain a new vision of their bodily functions, helping them to understand their body and mind as an indivisible whole. Thus he manages "to facilitate considerations of body-mind continuities, grounded in the reality of our moment-to-moment experience of ourselves as physiologically embodied subjectivities."[22]

The artist's words reveal that he is concerned with the unity of body and mind in a phenomenological sense. Unlike Davies's *Osmose*, *Cardiomporphologies v.2* is not an immersive environment but a work based on user-to-screen interaction. Participants perceived the visuals as an accurate reflection of their inner feelings and thoughts; one participant for example

20 E. Bartlem, "Reshaping Spectatorship: Immersive and Distributed Aesthetics," *The Fibre-culture Journal* 7 (2005).

21 Khut, *Development and Evaluation*, 148.

22 Khut, *Development and Evaluation*, 174.

Figure 4 George Khut. *Cardiomorphologies v.2* (2005). Interactive installation

© 2005, George Khut

claimed that the lights went out when he thought about his girlfriend; another participant saw the soothing visuals as an effect of his inner calmness. Some users tried to control the visuals by altering their breathing and later described the process as a "joyful experience"; others noted that the rhythm of the visuals had an impact on their breathing.[23]

Khut's art reveals that as biofeedback art reaches a wider public in the form of wearable technologies and mobile applications, our technological bodies constantly redefine the methods of perception and discover new paths for knowledge.

Mobile Feelings: Alternative Paths of Communication

Interacting with others via technological devices is taken for granted in today's world; mobile technology and the Internet have created the imperative

23 For more details about the reception of the work, see L. Muller, G. Turner, G. Khut, and E. Edmonds, "Creating Affective Visualisations for a Physiologically Interactive Artwork," in *Proceedings of the 10th International Conference of Information Visualisation* (Los Alamitos, CA: IEEE Computer Society, 2006): 651-658.

that one needs to be connected and reachable at any time. Furthermore, the evolution of social networks has generated the urge to share intimate thoughts and private information with a large group of people.

It is certain that information technology enhances communication; however, with the exchange of words and images, an important part of communication is lost, for example, eye-to-eye contact and the impact of a person's presence. Christa Sommerer and Laurent Mignonneau sought a way to transmit this part in *Mobile Feelings II* (2003). The artwork is comprised of small handheld devices that capture and transmit breathing and heart rate by means of a combination of electromechanical actuators, vibrators, and fans (see figure 5). The breathing rhythm and pulse of the person holding the device is transferred to another device held by another participant in the form of a light breeze and a pulsing light respectively.

This work highlights the role of non-verbal communication, which is often intuitive and less premeditated than speech. It also encourages participants to focus on touch, as the reception of the artwork showed. Some people who experimented with the work said it was a good "flirting tool," as it allowed them to get closer to each other without talking.[24] Others noted that they felt as if they were "holding each other's heart in their hands."[25] Feeling someone's breath and heartbeat is the kind of intimacy that exists only between friends, family, and lovers. For this reason, the work was met with aversion by some participants who felt their privacy was being invaded, while it appealed to others who found the experience comforting and sensual.

Even though the question of intimacy created ambivalent feelings in participants, most of them agreed that in order to sense the pulse of the other person, they had to focus on touch, thus reducing the other sensory input channels. Therefore, the artwork revealed a different path of perception that was not related to vision, the predominant sense when it comes to experiencing a visual artwork – and most practices in the Western world. One could argue that *Mobile Feelings II*, when viewed in relation to aesthetics, defies Baumgarten's separation between "higher" senses belonging to the mind and "lower" ones belonging to the body. It thus brings us closer to a more complete phenomenological experience of the world. This observation is also based

24 C. Sommerer and L. Mignonneau, "Mobile Feelings: Wireless Communication of Heartbeat and Breath for Mobile Art," in *International Conference on Artificial Reality and Telecommunication Proceedings* (Seoul: ICAT, 2004): 346-349.
25 G. Stocker, C. Sommerer, and L. Mignonneau, *Christa Sommerer and Laurent Mignonneau: Interactive Art Research* (Vienna: Springer Verlag, 2009), 207.

Figure 5 Christa Sommerer and Laurent Mignonneau. *Mobile Feelings II* (2003). Interface devices

© 2002-03, Christa Sommerer and Laurent Mignonneau

on the fact that Sommerer and Mignonneau establish a direct way of communication between artwork and public as well as between users and their bodies. After focusing on these mobile devices for a while, users inadvertently synchronize their breathing and thus establish proximity based only on their body. The synchronicity of breath as a means of communication is a subject that is also explored by Thecla Schiphorst, as we shall see next.

Exhale: Wearing the Body

Thecla Schiphorst's work also focuses on undoing the dichotomies between body and mind, artwork and public. However, she chooses a different approach with regard to the communicative dimension of her work. She works within a context in which body expression has always been the main focus: performative arts. As she observes, "There is a common ground that exists between the domains of HCI and performance practice: the need to model human experience."[26] Human-Computer Interaction (HCI) and

26 T. Schiphorst, "From the Inside Out: Design Methodologies of the Self," *CHI Workshop* (2007).

performance art both "decode" human gestures as a way of being in the world, exploring life and body experience. Schiphorst applies "performance methodologies to the design of technologically mediated experiences and spaces centred in ambient and wearable technologies: technologies that live close to the body."[27] She enhances performative expression through the use of technology; apart from the movements and gestures that are within the scope of the performative arts, she adds a new insight into the inner body by measuring the heart rate, breathing rhythm, and body temperature.

Exhale (2007) is based on a suit of high-tech garments that measures the breathing rate of the person wearing it and simultaneously communicates the breathing rate to another person or group of people wearing the same suit. The artwork permits three kinds of interactions: self to self, in which users observe their own breathing; self to other, where one participant selects to communicate his or her breathing pattern to another person who receives it as subtle ventilation under his or her skirt; and self to group, in which all users synchronize their breath and thus activate dimming lights on the surface of their skirts. The artwork functions on many levels, combining self-understanding, communication, and collaboration.

The participants who wore those dresses during workshops mentioned a feeling of calm, introspection, and of being at ease with the sounds and motions generated by the dress. It is interesting to see, in comparison to the interactive works mentioned above, that the combination of physi-cal and technological elements has the same effect of tranquillity on the participants who rediscover the rhythm of their body. At the same time, when breath is not only used as a meditative tool but also as a means of com-munication between users, it leads to a strong feeling of being connected to others, as the participants noted.[28] It seems that the use of biofeedback technologies in interactive art generates a distinctive response in partici-pants, who are not distracted by the interface – as is often the case with digital technologies – but are eager to know how they can use it to connect to their body and to others.[29]

Schiphorst stresses that breathing is a means of communication: sub-consciously we might be synchronizing our breaths when we try to align

27 Schiphorst, "From the Inside Out."
28 For more detailed observations by the participants, see T. Schiphorst, *The Varieties of User Experience: Bridging Embodied Methodologies from Somatics and Performance to Human Computer Interaction* (PhD diss., University of Plymouth, 2008), 186-194.
29 C. Salter, *Entangled: Technology and the Transformation of Performance* (Cambridge, MA: MIT Press, 2010), 338.

communication non-verbally.[30] In her work she explores alternative ways
of self-expression, combining breath control and interactive technologies,
illustrating the indivisibility of mind and body, artwork and participants.

Conclusion

The introduction of information technology into the world of art changes
the way the public perceives the artwork and relates to it. The public, ac-
customed to being engaged in everyday activities that take place in the
digital realm – from e-mailing to generating content online – expects to
be given a certain autonomy within the art space and looks forward to
participating. Following a phenomenological approach and focusing on
breath-related cultural practices, one can understand how interaction
can become a cognitive process with an impact on the participant – both
on a conscious and subconscious level. Interactive art affects how people
experience and perceive of their own body. Within this context, technology
becomes a medium: "The experience of one's 'body image' is not fixed but
malleably extendable and/or reducible in terms of the material or tech-
nological mediations that may be embodied."[31] Subsequently, our bodies
and our relations with technologies define who we are and how we think.

Rather than a "finished product," interactive art is process oriented, "a
frame or context which provides an environment for new experiences of
exchange and learning."[32] This transforms the museum or art space into
an art laboratory, a place where artists and visitors meet and create mean-
ing together. In this context, it is crucial that the established boundaries
between artist and public, art space and public space are eliminated, so that
people feel free to enter and become engaged in the artistic action. When
possible, artists and curators should make a conscious effort to welcome
into the art spaces those social groups who feel excluded from cultural
creation. Whereas participation from a broad social spectrum depends
on several factors such as cultural strategies and politics of inclusion, the
use of interactive technologies that depend on bodily movements may
impact social relations if it encourages participants to become actively

30 T. Schiphorst, "Breath, Skin and Clothing: Using Wearable Technologies as an Interface into
Ourselves," *International Journal of Performance Arts and Digital Media, PADM* 2 no. 2 (2006):
171-186.

31 D. Ihde, Technics and Praxis: *A Philosophy of Technology* (Dordrecht: D. Reidel, 1979), 74.

32 M. Lovejoy, *Digital Currents: Art in the Electronic Age* (London: Routledge, 2005), 168.

involved into an understanding of the body and the surrounding world. As they gain a better understanding of their body and its connection to the world, participants may even reach a meditative state during the interactive experience.

Within interactive environments that are based on biofeedback technology, the participants find themselves in a world built upon their heartbeat and breathing rhythm, the music of their body. Breaking through protective glass and disregarding signs, art reaches the people beyond the rigid spaces of the museum and the traditional modes of perception – thus becoming an everyday experience.

4 Curiosity and the Fate of Chronicles and Narratives

Chiel van den Akker

In the center of Anton Raphael Mengs's 1772/3 allegorical ceiling fresco of the Museum Clementine in the *Camera dei Papiri* of the Vatican, Clio (History) writes in her book as she watches Janus Bifrons (Past and Future) pointing to the statue of a sleeping Cleopatra in the museum (see figure 6).[1] The foundation of the Museum Clementine is recorded for posterity. The personification of fame and glory, Fama, too points to the museum, and on the left a Genius (the museum's "soul"?) carrying several scrolls of papyrus is depicted. It is striking that Clio has placed her book on the shoulders of Chronos (Time), who, while sitting on the floor, gazes at an epigraph only he has in view. This epigraph is a testimony of the pagan past, subjected to decay and in danger of being forgotten. The message we may infer from this fresco is that the museum, like history, keeps the past alive while time passes: that is history's triumph over time.

Preserving what would otherwise be lost is one of the tasks of the (art) history museum and an important reason for its existence. Obviously, (art) history museums have other tasks as well, and the task of preservation is not limited to this type of museum. In this chapter I am concerned with the representation of the past in museums.

Mengs's ceiling fresco also appears in Wolfgang Ernst's essay on virtual museums. In his "Archi(ve)textures of Museology" he observes:

> Two regimes conflict here: registering and description on the one hand
> and historiographical narrative on the other. On the borderline between
> history and archaeology, it is not clear what Clio is doing in the museum:
> is she writing in a book or entering items in a register? Her attention is
> diverted by Janus, who points to the realm of the aesthetic (represented by
> Cleopatra/Ariadne in the museum), whereas in fact what is brought to her
> is data. Instead of being a history of art, her book might be an inventory,
> appropriately placed in this painting on the shoulders of Chronos.[2]

1 An extensive description of this fresco is offered by S. Röttgen, "Das Papyruskabinett von Mengs in der Biblioteca Vaticana," *Münchner Jahrbuch der bildenden Kunst* 31 (1980): 189-246.
2 W. Ernst, "Archi(ve)textures of Museology," in *Museums and Memory*, ed. S.A. Crane (Stanford: Stanford University Press, 2002), 17-34 (23). The statue of a sleeping Ariadne in the Museum

The distinction between archaeology and art history is formulated in dichotomies. Register and book, inventory and narrative, data and aesthetics; they belong to opposing *knowledge* regimes.[3] (The distinction is not between academic disciplines.) Ernst favors the regime of archaeology (registration and description) above the regime of history (narration); the historical narrative has no place in the virtual museum.

We may doubt whether the opposition between these regimes is as stark as Ernst suggests. If we doubt that, we may still accept that the opposition has a heuristic function that enables us to conceptualize the online museum and the way it represents the past, even if we disagree with Ernst's interpretation of Mengs's fresco. As for the latter, Clio's attention does not seem to be diverted by Janus Bifrons at all, for does she not eagerly await him to separate the past from the present and the future? She knows that this is something that Chronos cannot do, for he merely counts days, one after the other, for all eternity. History not only triumphs over time inasmuch as she is able to preserve what would otherwise be irretrievably lost. The real triumph is that Clio knows what Chronos can never *know*: how in retrospect the past acquires a meaning that, for contemporaries, it never could have had.

The distinction between the regimes of archaeology and history can be reformulated in terms of the distinction between the chronicle and the narrative, where the chronicle is defined as a list of items and the narrative as a retrospective view on events – with a beginning, middle, and end – and a central theme or "thought." Ernst, however, would disagree with this reformulation for, as a list of items, the chronicle easily lends itself to a linear chronological presentation of objects: a sequence of moments, one after the other. And it is this chronological order that is rejected by Ernst. Moreover, he rejects the regime of (art) history (narrative) precisely because it presents its objects in a linear chronological order.[4] Now, even if we admit this to be so, we should realize, which Ernst does not do, that the narrative's understanding does not follow from the chronological order of its objects, for as the narrativist philosopher of history Louis Mink maintains: "To comprehend temporal succession means to think of it in both directions

Clementine was until the end of the eighteenth century thought to represent Cleopatra.

3 This is a central theme in Ernst's work. See for example his collection of essays, edited and introduced by Jussi Parikka: Ernst, *Digital Memory and the Archive* (Minneapolis, MN: University of Minnesota Press, 2013). Michel Foucault's notion of archaeology inspired Ernst's work. I will not discuss that here and instead limit myself to Ernst's views in his "Archi(ve)textures of Museology" because in that essay the museum is central.

4 Ernst, "Archi(ve)textures," 18, 29-30.

Figure 6 Anton Raphael Mengs (1772/73). *The Triumph of History over Time: Allegory of the Museum Clementinum*. Ceiling fresco in the Camera dei Papiri, Vatican Library

Via Wikimedia Commons © Public Domain

at once, and then time is no longer the river which bears us along but the river in aerial view, upstream and downstream seen in a single survey."[5]

The chronicle and the narrative are not the only models with which to represent the past, and sometimes these models are explicitly criticized by contemporary museum theorists. As an alternative, museums may display objects in small discontinuous historical series that do not belong to an encompassing (master) narrative. They can also present objects from different times in an order of co-presence: an eternal present tense that denies each object's past and future. This is the model that Ernst argues for.[6] The display of objects may further aim at a sense of immersion into the past, abolishing the distance between past and present, and with it the retrospective view that is characteristic of the (art) historical narrative. These three alternative models of representing the past may be realized using information technology on-site and online or by conventional means of museum display.

There may be other models to represent the past with, and many actual exhibitions are hybrids of these models. Here I am interested in the models I mentioned. In the first section of this chapter, I will compare the use of the chronicle and narrative in on-site (physical) museums with their use in online (virtual) museums. This section is followed by an analysis of the three alternative models of representing the past: the display of discontinuous historical series, the display of objects in an order of co-presence, and immersive display. In the third section, the chronicle and narrative will be evaluated in light of these alternatives.

The Old and the New

A comparison between the on-site and online museum is misleading in that it suggests that the models and concepts underlying online museum display are autonomous with regard to developments and insights in on-site museums and museum theory. To avoid this misleading suggestion, I will distinguish between the old and the new in addition to distinguishing between on-site and online museums. Some online museums use the chronicle

5 L.O. Mink, "History and Fiction as Modes of Comprehension," *New Literary History* 1 no. 3 (1970): 551-559 (554-555).
6 Ernst, "Archi(ve)textures," 30. Stevens recently also argued for the use of the order of co-presence in (virtual) museums. See M. Stevens, *Virtuele Herinnering. Kunstmusea in een Digitale Cultuur* (PhD diss., Radboud University, 2009), 90-91, 96, 114.

and the narrative in a similar way as conventional on-site museums do, whereas some on-site museums use alternative models of representing the past, similar to those used in some online museums. On-site (physical) and online (virtual) museums thus are either old or new, making use of conventional or innovative means of display. The point is that we should neither associate the "new" with digital technologies, as if a change of medium is innovative in itself; nor should we associate the "old" with the absence of digital technologies, as if the refusal to change the medium prevents innovation. (Below we will see that the most appropriate distinction between the old and the new is that between what Eilean Hooper-Greenhill refers to as the modernist museum and the post-museum.)

When comparing the on-site and online use of narrative, we should realize that the concept of narrative that is used may differ. On-site and online museums may use the same narrative model differently, or they may use different narrative models. Therefore I shall make a distinction between the old, panoramic, linear narrative, and the new, personal, interactively created narrative. Again we may question whether this distinction is as stark as I suggest, but this leaves untouched its heuristic function. The chronicle appears to be a stable concept, so there is no need to distinguish between the old and the new chronicle. We should, however, distinguish between the chronicle as a mere list of items and the chronicle as a linear chronological sequence of objects and events. Some differences between the on-site and online use of chronicles and narratives readily emerge. In what follows I will make several distinctions between "the old" and "the new."

In the conventional on-site museum, one either follows a route of chronologically ordered objects, room after room, period after period, or one sees a narrative gradually unfold while following the required route. Of course, visitors may do as they like (as long as their behavior is appropriate) and disregard the order that the museum provides, and curators in turn may anticipate such behavior. Nonetheless, visitors do take routes that either depart from the curated route or not. Online museums do not literally have such routes (with the exception of some odd online museums mimicking an on-site museum's floor plan); they have navigation paths instead. Still, here too the model used is a route to be taken by the visitor, even if the interface allows its users to take different routes or navigation paths. Moving through time as one moves through the museum is in accordance with the conventional museum model, where objects that are characteristic of certain periods and cultures are linearly ordered, and this model can be used in both on-site and online museums. This traditional model of museum display follows from the chronicle, taken as a chronological sequence of

objects, by definition; it follows from the narrative by convention, since the understanding of the narrative does not coincide with the chronological order of its signifying objects.

The Metropolitan Museum of Art, for example, provides its online visitors with the choice between Timelines and Thematic Essays (one can also select a region or search and browse their collection).[7] The Timelines section uses the chronicle as a model to present history; the Thematic Essays section uses the narrative. One such timeline is that of "Central Europe (including Germany), 1600-1800 AD." It presents empires, wars, and dynasties on a timeline, next to a short description of the period, descriptions of key events in their chronological order, and seventy-five works of art of the period, also in a chronological order. One can also view the reproductions of these artworks in a slide show, which presents them, again, in their chronological order. In this example, the chronicle is a list of chronologically ordered items concerning one topic. In the Timelines section one can navigate to one of the thematic essays via the related content section and leave the presentation of history by means of the chronicle behind. By choosing the essay "Neoclassicism" in the Thematic Essays section, a narrative is presented of the theme, and the objects in the museum collection are used to signify that theme.

The Metropolitan Museum of Art uses a conventional interface to provide access to its collection, giving their visitors a choice between timelines and (art) historical narratives. Many (art) history museum websites use a timeline to present objects and events, and some of them explicitly tell a story using objects to illustrate that story (general history museums probably do that more often than art history museums). The Smithsonian National Museum of American History is a case in point.[8] An event on a timeline, the Boston Massacre of 1770, provides entrance to an online exhibition called "The Price of Freedom: Americans at War." By selecting a conflict, "War of Independence" for example, a traditional, patriotic story on national history is told using objects to illustrate that story.

The old chronicle and narrative present their objects in a fixed order (we are not allowed to change the order of objects in a museum by rearranging its paintings and pottery). If we disregard this order by crisscrossing the museum, we have to memorize the objects seen if we want to compare them. A curated order, by contrast, allows direct comparison of objects for a reason. Exhibitions are designed to guide visitors through the museum,

7 http://www.metmuseum.org/. Last accessed 9 January 2014.
8 http://americanhistory.si.edu/. Last accessed 9 January 2014.

following the model used. In what we may refer to as the "new" museum, this no longer appears to be so (but we are still not allowed to change the order of objects in on-site museums, though this is easily done in online museums). Some museums are experimenting with alternative routes, thereby opening up the fixed order of objects as presented by the chronicle or the narrative. The Philadelphia Museum of Art, for example, provides the opportunity for visitors to create a personal online gallery of favorite museum objects, customize a tour, and share it with friends at the "My Museum" section.[9] Many museums facilitate such online access to their collections. Routes on online view, customized by the institution or the online visitor, can be taken on-site if visitors are enabled to plan their on-site tour in advance. Each different route, whether on-site or online, is a small narrative that unfolds while taking the tour. These narratives however are no longer panoramic historical narratives: they are personal narratives insofar as the museum's objects on the chosen route reflect the mood one is in and the interests one has. Linearity is exchanged for *interactivity,* and the *personal* view is preferred above the general panoramic view.

Another difference between the on-site and online use of chronicles and narratives is that the online chronicles and narratives are *variable*: they are made of building blocks that can be taken apart and recombined. Two chronicles on different topics may be recombined into a new chronicle with a new topic. The order of objects in a narrative can be rearranged, which either leads to the same narrative told differently (narrative under-standing, after all, does not depend on the chronological order of objects and events but on the theme holding those objects and events together in a comprehensive "thought" or theme), or to a different narrative (with a different theme). Objects that were once used to form a narrative are now recombined, providing a *collage* of perspectives. For example, as part of their ongoing 2010 Art ReMix project, the Minneapolis Institute of Art exhibits contemporary art amidst their permanent collection. Another part of the project is the juxtaposition of two artworks or other objects (a photograph of people gazing at an artwork for example) on their website. According to the online announcement of the project, a remix provides "an alternative view or new perspective on art history and art-making." By juxtaposing contemporary and historical works of art, contemporary art "enriches the story."[10] The story to be enriched is presumably the canonical master narrative on art history that is usually found in textbooks.

9 http://www.philamuseum.org/. Last accessed 9 January 2014.
10 http://www2.artsmia.org/blogs/art-remix/. Last accessed 9 January 2014.

Juxtaposing artworks from different times no doubt provides an alternate view on art history and art-making. By seeing one work in terms of the other, the *meaning* of both is affected. More important in the context of this chapter is the implicit criticism of conventional models of museum display in the Art ReMix project. Obviously, the chronological order of artworks is explicitly criticized by disregarding it. It criticizes the chronicle by exhibiting objects in an order of co-presence, denying their origins in different epochs. Art history is criticized by not taking it as the starting point of the exhibition; instead, art history functions as a point of reference of what the juxtaposing of artworks does not lead to – affirming the (canonical) art historical context of the works.

This last criticism is interesting in that it assumes that the artwork provides the context, whereas traditionally an artwork is situated in a historical context. The insight we may infer from this is that it is a mistake to believe that there is, first, a ready-made historical context, and, second, an object (an artwork or other artefact) that can and should be placed in that context. It is precisely the other way around: objects provide the context for comparison, insights, and deliberations. One advantage of online collections is the relative ease with which the opportunity can be offered to many diverse users to have such a learning experience. It is important to note that, regardless of whether this insight is true or not, it does not follow that we should stop using (art) historical narratives; it follows that the narrative should not have priority over objects. Objects, after all, should give the narrative, and this function should depart from the object. To bring this about, the object should be central, and museums should find a balance between telling too little and telling too much. When there is too little to go on, the object will not tell anything. If there is too much to go on, the narrative does not need the object to be told.

The Art Remix project also implicitly criticizes the authoritative, single voice of the curator and (art) historian. This brings me to the last distinction I want to make between the old and the new. The old historical narrative is characterized by the retrospective view of its author: the historian or curator. Like the chronicle, which is also a monographic model, it no longer seems to fit our present-day participatory culture.[11] The old narrative provides a single authored voice (even if a team of curators work on an exhibition, they will still speak with a single voice in the old museum), while the new narrative, a collage rather than a panoramic view, is multiple-authored, allowing

11 A. Rigney, "When the Monograph is no Longer the Medium: Historical Narrative in the Online Age," *History and Theory* 49 (2010): 100-117 (106).

for the coexistence of different voices. Breaking up the old chronicle and narrative and the introduction of multiple authorship are two sides of the same coin. The new museum, or post-museum, as Eilean Hooper-Greenhill calls it, is a site of *mutuality*.[12] This is true of the new on-site and online museums. As a consequence, the authoritative, single voice of the historian and curator is exchanged for a multitude of viewpoints, a lot of consenting and dissenting voices.

The pluralism embraced by our present-day participatory culture manifests itself in alternatives to (art) history. They are personal, interesting, entertaining, and creative views on objects. One thing should however be taken into account: identifying a view as an alternative requires knowledge of what it is the view is an alternative to. Something is only new or alternative relative to what is old and already known. Alternative routes may easily turn out to be other routes.

The New

Recently Beth Lord argued against the use of object to illustrate stable concepts (e.g. colonialism and neoclassicism) and the understanding of history as a "fixed and continuous line along which events and objects are placed."[13] This criticism does not imply the abandonment of the narrative per se. What Lord seems to reject is the modernist master narrative, that is, the old, progressive, panoramic narrative of Art, the Nation, Nature, or Man.[14] Such modernist master narratives are now typically found in textbooks, and they may still influence current, more conventional museum exhibitions. To be sure, one can write a panoramic narrative without writing a modernist narrative of progress and regardless of the topic one deals with (even the well-known micro-histories provide panoramic views of at least one century).

Lord discusses the Museum of America in Madrid, which she considers to be a good example of an alternative to traditional exhibition practices.

12 E. Hooper-Greenhill, *Museums and the Interpretation of Visual Culture* (London: Routledge, 2000), xi. The conflict between the single-voiced narrative of the past and the pluralism of personal viewpoints is much emphasized, for example by G. Black, *Transforming Museums in the Twenty-First Century* (London: Routledge, 2012), 145.

13 B. Lord, "From the Document to the Monument: Museums and the Philosophy of History" in *Museum Revolutions*, eds. S. Knell, S. Maclead, and S. Watson (London: Routledge, 2007), 355-366 (360).

14 For this description, see Hooper-Greenhill, *Museums*, 24-25.

"Instead of starting with one continuous history or one total concept of a culture and using the objects to illustrate it, the Museo de America starts with the *objects* and relates them to develop discontinuous historical series."[15] Lord emphasizes that she is not arguing for a focus on objects only, for that would turn objects into artworks to be appreciated aesthetically; history museums, after all, are in the business of communicating history. The Museum of America

> treats its artefacts as historical documents, but not as particulars through which the visitor is supposed to connect with a universal concept or fixed continuity of history. Objects are not made to refer to anything, but *taken together* in small groups they are starting points for developing micro-histories. A seventeenth-century Peruvian pot is shown amid Peruvian pots from different centuries up to the present day. In the next case, Mayan religious objects are shown alongside Catholic religious objects, used around the same time in the same area.[16]

These two groups of objects, each constituting a small historical series, are discontinuous with one another. Instead of transmitting a fixed idea about colonialism and Peruvian culture, it makes clear to visitors that objects can be used to make different histories. The objects are presented in an order of co-presence, since pots from different centuries and different religious objects are shown together, simultaneously, side by side. This alternative model of representing the past is not limited to on-site (physical) museums and is easily applied to online (virtual) museum display. Moreover, online visitors may curate such discontinuous historical series themselves.

Lord also emphasizes the visitor's involvement in the exhibition. The visitor is "encouraged to *do a kind of history*" by constructing the discontinuity between the series. As a result, they will leave the museum with a view "of history and culture as complex, puzzling and irreducibly multiple – and of history as a practice that *involves* the visitor."[17] This emphasis on "involvement" is in line with the new or post-museum as a place of mutuality and the changing roles of curators and visitors in such a museum: the curator is no longer the authoritative narrator and the visitor is no longer the passive recipient. As Hooper-Greenhill contends: "In the post-museum, histories

15 Lord, "From the Document," 359.
16 Lord, "From the Document," 361.
17 Lord, "From the Document," 361.

that have been hidden away are being brought to light, and in this, modernist master narratives are being challenged."[18]

The Museum of America in Madrid is in accordance with Ernst's plea to favor the regime of archaeology above the regime of history in virtual museums. The artefact is central and should not be used to signify a continuous development or stable concept. Instead of panoramic historical narratives, discontinuous historical series are explored by visitors, leading to a collage of viewpoints in the online museum. In this view, the museum object is an item in a possible discontinuous historical series involving the visitor, just as it is for Lord. The order of co-presence of objects in virtual museums is an alternative to both the chronicle and the retrospective, panoramic, historical narrative. One of its consequences is that the insight of late eighteenth-century German Romanticism not to measure the past by contemporary standards – the founding insight of modern historical consciousness – no longer appears valid, for what was once past is now measured in terms of an eternal present. The distinction between past, present, and future on which history (narrative) is based is no longer considered to be useful; beginnings, middles, and ends will become obsolete. Ernst observes:

> Beginning *medias in res*, the virtual museum visitor navigates on the monitor through the Internet where (s)he faces a kind of profusion of data that might deter traditional archivists, librarians, and museum directors. The digital wonderland signals the return of a *temps perdu* in which thinking with one's eye (the impulse of *curiositas*) was not yet despised in favor of cognitive operations. Curiosity cabinets in the media age, stuffed with texts, images, icons, programs, and miracles of the world, are waiting to be explored (but not necessarily explained).[19]

A curiosity cabinet presents its objects instantly as separate items, favoring the visual above thought and reflection. This is what the new online museum looks like. This *ricorso* to curiosity is, according to the cultural historian Stephan Bann, part of a larger development in museum display. He speaks of "the long-term effect of the weakening of the paradigm of

18 Hooper-Greenhill, Museums, 145.
19 Ernst, "Archi(ve)textures," 30. Müller contends: "the Web is ... a cabinet of wonders and curiosities. Everything is just a click away." See K. Müller, "Museums and Virtuality," in *Museums in a Digital Age*, ed. R. Parry (London: Routledge, 2010), 295-305 (301). Stevens observes that with the virtual museum "surprise and curiosity return to the exhibition space." Stevens, *Virtuele Herinnering*, 111.

historicism, which has for at least two centuries dominated the classification and display of the visual arts in the West." Curiosity, so Bann tell us, makes clear that the object displayed is "invariably a nexus of interrelated meanings – which may be quite discordant – rather than a staging post on a well-trodden route through history."[20]

The possibility offered by some online museums to create a personal selection of objects, a curiosity cabinet of one's own making, and the display of small discontinuous historical series, encouraging visitors to make their own historical connections, are not the only means of stimulating curiosity and the creation of personal perspectives on objects. A third central concept in contemporary museum theory alongside discontinuity and co-presence is the concept of immersion. This I turn to now.

The aim of immersive display is to have visitors take a leap backwards and replay the past by means of *empathy*.[21] Autobiographical stories of historical agents, reenactments, 3-D modelling, video games,[22] simulations, and (virtual) reconstruction, all aim at such *aesthesis*, either in on-site (physical) museum settings or in online (virtual) environments.[23] Experiencing the past as then-contemporaries experienced it is preferred to the retrospective point of view of the narrative, a view which is a necessary condition of the awareness that the immersion itself provides the *illusion* of experiencing the past as then-contemporaries experienced it. The chronicle underlies

20 S. Bann, "The Return to Curiosity: Shifting Paradigms in Contemporary Museum Display," in *Art and its Publics: Museum Studies at the Millennium*, ed. A. McClellan (Malden: Blackwell, 2003), 117-130 (120). On this return to curiosity, see also M. Henning, *Museums, Media, and Cultural Theory* (New York: Open University Press, 2006), 143-154.

21 Lord, "From the Document," 358. Lord identifies what I take as the aesthesis of history as an old model which she opposes. This model she describes thus: "Understanding and interpreting the museum object involves recognising its concept, replaying its truth and rediscovering the self through empathic connections with the object." 358. What is missing in Lord's essay is the retrospective narrative, which is the true opposite of what she refers to as empathy and replaying the past.

22 For immersion in video games, see W. Kansteiner, "Alternate Worlds and Invented Communities: History and Historical Consciousness in the Age of Interactive Media," in *Manifestos for History*, ed. K. Jenkins et al. (New York: Routledge, 2007), 137-139.

23 Griffiths argues that there is a "sense of *déjà vu* pervading contemporary debates about the uses of digital technology in museums, with curators facing many of the same challenges that their predecessors faced." (384) One such debate is about evoking "the sensory experience of immersion and time travel." (383) The new museum is thus not as new as it seems. A. Griffiths, "Media Technology and Museum Display: A Century of Accommodation and Conflict," in *Rethinking Media Change: The Aesthetics of Transition Account*, ed. D. Thorburn et al. (Cambridge, MA: MIT Press, 2003), 375-389. Grau discusses several historical and contemporary examples of immersion in his wonderful book. See O. Grau, *Virtual Art: From Illusion to Immersion* (Cambridge, MA: MIT Press, 2003).

this alternative model in that time is considered to be a series of instances one can hop into. The chronicle, then, is not used to present history; it is used to immerse the visitor in history.

Immersive museum display turns the on-site and online museum visitor into a contemporary of the object, similar to the presentation of objects in an order of co-presence, an eternal present sense of which both the object and the visitor are part. There is, however, a fundamental difference between these two alternative models of representing the past. Immersing oneself in history gives one the illusion of being a contemporary of historical agents, thus abolishing the distance between past and present, whereas the order of co-presence turns the visitor into a contemporary of the historical agent and the objects associated with him, thus categorically abolishing the past and the future.

The emphasis on providing experiences is a key characteristic of contemporary museum display.[24] In narrative theory too there is shift from a focus on narrative structure to studying narrative effects such as immersion and experience, a shift to the analysis of how readers "become imaginatively immersed in the lives of others and in worlds other than their own," as Ann Rigney puts it. According to Rigney, this shift is a response to the emergent information technology, which allows new sorts of interaction and new immersive virtual environments.[25] There is no reason to doubt the truth of this observation; there is, however, a crucial difference between the contemporaneous or historical agent's point of view and the retrospective or historian's point of view. The shift of attention in narrative theory that Rigney refers to either does not apply to historical narratives, for which the retrospective view is essential, or the retrospective historical narrative is becoming a thing of the past.

The Old

On the one hand, there are reasons to doubt whether the chronicle is still a viable model of representing the past on-site and online. On the other hand, we may think that the computer is an ideal chronicler, for it can generate a complete list of all objects and events including the experiences and observations of contemporaries of those events. It can register when something was made, the way it was made, and for what reason it was

24 Hooper-Greenhill, *Museums*, 143
25 Rigney, "When the Monograph," 108-109.

made. There is, however, one important and decisive shortcoming of such machines, as the late American philosopher Arthur Danto points out.[26] The Ideal Chronicler has no knowledge of the future: it simply registers when the object is made, collected, exhibited, damaged, admired, and discarded; all of which are descriptions from a contemporaneous point of view. When the Metropolitan Museum of Art's website states that in 1618 the Thirty Years War began with the Defenestration of Prague, a statement presupposing knowledge of the future of that event is made, for only *after* 1648 did it make sense to state that in 1618 the Thirty Years War had begun. The statement "In 1618 the Thirty Years War began" thus cannot be part of the Ideal Chronicler's list. We should also realize that not one of the Protestants throwing the two Habsburg regents and one of their secretaries out of the window did so with the intention of starting a thirty years war. Contemporaries cannot view the events they witness or participate in from the perspective of the historian or curator. This limitation to *Verstehen* neither makes the procedures of understanding past thoughts and experiences redundant, nor is it to be taken as a criticism of immersive museum display which aims to provide a sense of experiencing the past as then-contemporaries experienced it. It does, however, mark a fundamental difference between the chronicle – a list, inventory, or sequence of descriptions of objects – and the narrative, which presents a development to which objects contribute and which is seen from the retrospective view of the historian or curator.

Another important difference between the chronicle and the retrospective narrative is that the former is a realist model in that it wants to map the past as it was for those witnessing and experiencing it. As such it is in accordance with the museum as an inventory of the world, telling its visitors "what is" with the objects they showcase. It is also in accordance with the conception of the web as a storehouse of information, a database of items waiting to be ordered and explored by its visitors. The narrative, by contrast, is an idealist model in that it aims at understanding the past by means of panoramic views that had no existence in past reality itself.[27] Idealist philosophy of history holds that history rather than being found in past reality results from retrospective understanding.[28]

26 A. Danto, *Narration and Knowledge* (New York: Colombia University Press, 1985), 143-181.

27 F. Ankersmit, *Narrative Logic. A Semantic Analysis of the Historian's Language* (The Hague: Martinus Nijhoff, 1983), 75-89.

28 C. van den Akker, "The Exemplification Theory of History: Narrativist Philosophy and the Autonomy of History", *The Journal of the Philosophy of History* 6 no. 2 (2012): 236-257.

This idealist model fits the old museum as a place of contemplation, telling its visitors how what there is should be understood by having objects signify historical developments that only come into view in retrospect. It may, however, also fit the new museum as a place of mutuality, for there is no reason to argue against fixed and continuous narratives in favor of discontinuous historical series involving the visitor when it is realized that both continuity and discontinuity are the result of historical understanding. Moreover, the same object may be used to tell different stories, so there is no reason to assume that the narrative automatically leads to an understanding of history as fixed and stable, as Lord thinks, as long as visitors are encouraged to have an understanding of objects as potentially telling different stories. Finally, (historical) art and artefacts should not merely tell us what the past was like; they should make us aware of the difference between the past and the present, and with that, of what we are no longer. In this conception, objects are to be understood retrospectively.

On the one hand, the chronicle, as a list of items, is conceptually related to the order of co-presence, for the latter too leads to an inventory of items. On the other hand, it is not, since the order of co-presence rejects the chronicle by its refusal to be ordered chronologically. The chronicle is also conceptually related to immersion in that immersion aims at taking the contemporaneous point of view, following the sequence of instances that is characteristic of the chronicle.

If we were forced to choose between the chronicle and the narrative, we would have to choose the latter from the perspective of historical understanding, for, as Danto observes, "the whole point of history is not to know about actions as witnesses might, but as historians do, in connection with later events and as parts of temporal wholes," that is, with the help of narratives.[29] The aesthesis of history aims at providing the illusion of experiencing the sight and sound of the past itself. As such it is a promise of doing without history, for if we would be satisfied with experiencing the past as then-contemporaries experienced it, the historical retrospective narrative would be redundant. Now we may appreciate Allan Megill's warning that the aesthesis of history withholds us from experiencing "a rift, a break, between what *we are* now and what *others were* then."[30] The contemporaneous point of view does not allow the experience of such a break. Displaying objects in an order of co-presence also turns the visitor

29 Danto, *Narration*, 183.
30 A. Megill, *Historical Knowledge, Historical Error: A Contemporary Guide To Practice* (Chicago: University of Chicago Press, 2007), 213.

into a contemporary of the object, abolishing the past *and* the future (the one cannot exist without the other) in favor of the present (which can exist without the past and the future). Obviously, the presentation of objects in an order of co-presence lacks the retrospective view of the historical narrative too.

Conclusion

Karsten Harries once wrote that "what needs preserving does so precisely because it has lost its place in our world and must therefore be given a special place."[31] This explains why the Museum Clementine preserved the pagan epigraph, the sleeping Cleopatra, and the papyrus scrolls of early Christianity. Danto agrees with Harries when he observes that the place such objects "once fit into no longer is open," which means, among other things, that in normal circumstances, it no longer makes sense to speak about them in the present sense: it is their *fate* to be spoken about in the imperfect.[32] Here the past and the present are separate realms: the past is identified with the retrospective point of view, and the present is identified with the contemporaneous point of view. Rather than being simply a chronological distinction, a matter of determining what happened before and what comes after, the distinction between past and present is a distinction in modality. What no longer belongs to our worlds is something that no longer can be seen from a contemporaneous point of view. This may provide a ground for the existence of museums. We have (art) history museums to preserve what no longer belongs to our world, as reminders of what has been and is no longer, and by extension, of what *we* have been and are no longer.

Throughout this chapter I have identified the present with the contemporaneous point of view, the past with the retrospective point of view, and the future with the anticipatory point of view. It helped us to distinguish between the chronicle and the old and new narrative, and it enabled us to discuss the three alternative models of representing the past. The conclusion is not that the chronicle and narrative are *the* two basic models from which other models are derived. Rather the distinction between the contemporaneous and the retrospective point of view is basic, for this distinction enabled us to compare the different models. The following conclusion now seems warranted: The discontinuity of unconnected and plural historical

31 K. Harries, "Hegel on the Future of Art," *Review of Metaphysics* 27 (1974): 677-696 (678).
32 Danto, *Narration*, 295.

series, the eternal present tense of objects in the new on-site and online museums, and the promise of immersive technologies to open all worlds, point in the direction of an a-historicist "archaeological" relation with the past. Janus might allow it, Chronos would rejoice, Clio, however, would regret it, for History would no longer triumph over Time.

Acknowledgment

Research for this chapter was funded by NWO, the Netherlands Organisation for Scientific Research, under the CATCH-Agora programme, grant 640.004.801.

5 Networked Knowledge and Epistemic Authority in the Development of Virtual Museums

Anne Beaulieu and Sarah de Rijcke

A strong trend in the design and presentation of museum collections is to involve networked digital databases in these activities. In the context of museums, digital images traditionally have a documentary function, so that images have been posited as referents for objects that one might encounter during a visit (ethnographic objects, books, maps, etc.). We have found that when digital images are part of networked databases, the way they take on instrumental and authoritative roles affects tradition and supports new practices. Images become more mobile, more spontaneously generated or created, or travel more easily from one technological platform to another. Furthermore, the intersection of digital and network technologies also means that images can be related to each other in new ways, within databases or with other resources on the web, and that they serve as support for mediated social interactions such as sharing, discussion, or annotation. The images themselves become the focus of forms of engagement and of embedding that shape access and production of knowledge. They should not be seen as mainly representing museum objects.

In this chapter, we analyze new practices in the context of an ethnographic museum in Amsterdam: the Tropenmuseum. This is a useful case for at least two reasons. First of all, the museum extensively uses a web-based collection database of images in a system called The Museum System (TMS). Interestingly, the database not only shapes much of the institutional work processes within the museum, but it also (re)defines what counts as the collection and how other users can interact with the museum collection via digital images. Second, the database increasingly configures images as interfaces to other types of information and activities.

At the Tropenmuseum, the main institutional investments around collection management were made in the development of the web-based image database TMS. Put into use in 2000, it carried multiple promises – of improving management, modernizing the museum, and of enabling the museum to take better care of its collections. In addition, the museum explicitly aimed to use the database to change user interaction with the

collections, both for employees and for visitors of the museum and of the museum's website. There was also the hope that the networked database would diminish the number of times museum employees would need access to the depots, by replacing the practice of handling physical objects by that of consulting a collection database.[1] The database was also introduced with the goal of making the museum collections available for a wider audience via the web and to help increase the number of visitors, both to the website and to the museum. Accessibility for the communities from which objects originated was also signalled as a valuable role for the website.

While TMS influences interactions with the museum collections in important ways, other projects also change the role of users with regards to the Tropenmuseum collections. At the time of our fieldwork at the Tropenmuseum in 2009, the museum was also investing in other distributed infrastructures for visual knowing. Several of these initiatives focused on involving new users by using images as interfaces. These projects can be seen as part of an international trend that was taking off in the first decade of this century.

The fieldwork used in this research was inspired by ethnographic methods as adapted by STS to settings of knowledge productions such as laboratories, repositories, and archives. It consisted of systematic participant observation, open-ended interviews with museum staff and visitors, a detailed scrutiny of new web-based initiatives around the museum collection, and an examination of official policy documents, relevant archival material, and funding applications relating to digitization and information management. Theoretically, the analysis is inspired by two bodies of work: new media theory and science and technology studies (STS). New media studies help to analyze mediated interaction with images. It enables us to relate these various interactions with other spheres of visual culture and to variations in the history of representations.[2] The body of STS literature we draw on helps us situate the relationship between new technologies (and innovation more generally) and the development and circulation of new

1 The objects are also transformed as part of the Tropenmuseum's digitization strategies. They were all given a bar code label. This label changes what counts as the objects and links each one to a particular information infrastructure, to new ways of accounting and knowing about collections and of managing working routines in the depots.

2 L. Cartwright, *Screening the Body: Tracing Medicine's Visual Culture* (Minneapolis: Minnesota University Press, 1995); J. van Dijck, *The Transparent Body* (Seattle: University of Washington Press, 2005); S. de Rijcke, "Drawing into Abstraction: Practices of Observation and Visualisation in the Work of Santiago Ramon y Cajal," *Interdisciplinary Science Reviews* 33 (2008): 287-311; S. de Rijcke, "Light Tries the Expert Eye: The Introduction of Photography in Nineteenth-Century Macroscopic Neuroanatomy," *Journal of the History of the Neurosciences* 17 (2008): 349-366.

knowledge. In particular, STS theory enables us to consider knowledge in relation to material culture and to institutions such as archives, museums, and universities.[3] The vocabulary of STS is also useful in avoiding some a priori distinctions. For example, it was very useful for our analysis to borrow the term "users" from STS, to denote those interacting with a technology, and to consider how they organize and understand themselves.[4] With the label of users, we could consider a range of actors without first dividing them into producers and consumers, thereby avoiding the assumption that those outside the museum are consumers and those within are producers.

In the material that follows, we stress the active role of images and the variety of functions they serve besides a representational one in museums. When images are made into the focus and means of interactions, new activities and new kinds of work are pursued in and around museums. The role of the network cannot be underestimated, with far-reaching consequences for such institutions. The boundaries of images, collections, and institutions are challenged by this networked context, so that networked platforms emerge as a site where museums must formulate and pursue their mission. While such far-reaching shifts may feel threatening, we see these challenges as similar to those faced by other actors in contemporary visual culture. Bottom-up initiatives, crowd sourcing, and diversity of media coverage are increasingly of concern, above and beyond issues of digitization of collections.[5] We therefore argue that, considering these dynamics, digital images are crucial focal points to address how museums are changing as part of the digital turn.[6]

The Image as Interface

How to understand the fact that the images are increasingly multilayered objects on which to act in order to access knowledge? First of all, we need to take into account the characteristics of the visual culture within museums.

3 A. Beaulieu, S. de Rijcke, and B. van Heur, "Authority and Expertise in New Sites of Knowledge Production," in *Virtual Knowledge*, ed. P. Wouters et al. (Cambridge, MA: MIT Press, 2012); M. Hand, *Making Digital Cultures: Access, Interactivity and Authenticity* (Aldershot: Ashgate, 2008).

4 N. Oudshoorn and T. Pinch, eds. *How Users Matter: The Co-Construction of Users and Technology* (Cambridge, MA: MIT Press, 2003).

5 P.F. Marty, "The Changing Nature of Information Work in Museums," *Journal of the American Society for Information Science and Technology* 58 (2007): 97-107.

6 I. Mason, "Virtual Preservation: How Has Digital Culture Influenced Our Ideas about Permanence? Changing Practice in a National Legal Deposit Library," *Library Trends* 56 (2007): 198-215.

Museums have always ascribed a large role to the visual, according to Hooper-Greenhill, with their emphasis on the museum collection and the visual display of objects.[7] Hooper-Greenhill argues that display practices tend to enforce one-way communication and are difficult to modify because they are built into the structures and practices of institutions. Simultaneously, she notes that more recent trends do however emphasize two-way communication, more openness to the voices and expertise of visitors and users.[8] In addition, other tools and settings that also support such trends (such as information infrastructures, digitization, and new kinds of platforms for web-based interactions) are now being integrated in museums. The material culture of institutions is therefore changing in response to the use of digital images, which have a particular physicality and – like printed photographs – require an adapted environment for preservation, manipulation, and display (think of servers, scanners, screens, and lighting conditions). In the case of the Tropenmuseum, a particularly interesting development is the way both "field" or "archival" photographs and objects as traditional elements of museum knowledge are reconfigured as digital images. In this process, their respective roles as document and artefact shift as they acquire new materialities and as their historical function shifts. For example, photographs themselves may become historicized and function as evidence of culture in their own right – having their mediating effect highlighted – just as digitization purports to render them to the user in a transparent way. Our analysis therefore considers change and continuity in the use of images for knowledge production around museum collections.

Clearly, modes of visual mediation are heavily influenced by the visual-material culture and historical trajectories in museums. In the Tropenmuseum, the focus on the visual is deeply ingrained in the organization's digital archiving practices. The museum divides these practices up in three levels: the first level is basic registration, which is followed by registration and documentation.[9] The production of digital images of physical objects is a crucial element of basic registration. Earlier, analogue ways of documenting the collection used paper documentation on various kinds of inventory

7 E. Hooper-Greenhill, *Museums and the Interpretation of Visual Culture* (London: Routledge, 2000), 151.

8 See C. Joergensen, "'Unlocking the Museum: a Manifesto,'" *Journal of the American Society for Information Science and Technology* 55 (2004): 462-464. Also of interest is N. Simon, "The Multi-Platform Museum: Coming Live to You on May 18," (2009), message posted on http://museumtwo.blogspot.com/2009/05/multi-platform-museum-coming-live-to.html.

9 M. Beumer, *Capturing Museum Knowledge: Bulletins of the Royal Tropical Institute* (Amsterdam: Royal Tropical Institute, 2009), 9.

cards, sometimes accompanied by an explanatory drawing.[10] The Tropen-museum also has a long tradition of photographic documentation and has always had a large number of analogue photographs of the physical objects in the collection. Since the museum started working with the web-based collection database in The Museum System, both the paper documentation and the analogue photographs have been digitized and the information combined in digital media.[11] One of the central aims of the digital archiving was to make the collection more manageable, more accessible, and less prone to deterioration. The latter is based on the hope that "[t]he objects and [printed] photographs themselves no longer function as an 'information system.'"[12] Digital archiving is therefore motivated by belief in the substitutability of digital images of physical objects as well as by faith in the information management gains to be acquired through digitization.

In today's museums, existing practices around the production, handling, and dissemination of images of objects are increasingly blending with new networked technologies for visual knowledge production. Interaction and manipulation in a networked setting are integral to these practices, and they emphasize intervening rather than observing.[13] Increasingly, images become an interface that invites interaction on museum websites. For example, on the website of the Tropenmuseum, the collections can be searched, *and* for each item there is a photo and the catalogue information – information that resembles what was previously inscribed on catalogue cards. While the description is static, the image has built-in functionality. Users are invited to interact with it, either with the image itself in visual terms (zoom, crop, move) or with the image as a digital file in a networked setting (print, e-mail it, preserve it). They can also make it part of their very own selection and create their own space in the database. It is also very easy to take it out entirely and have it travel to other settings and to other media, including this publication.

These possibilities are crucial for the way knowledge can be created. Furthermore, they constitute an understudied form of visual knowing. In

10 Beumer, *Capturing Museum Knowledge*, 9.

11 The photographic collection has always been documented on different inventory cards. These so-called UDC cards included copies of the historical photographs, and they were further annotated with a description of the scene plus additional data relating to the origin. Beumer, *Capturing Museum Knowledge*, 32-37.

12 Beumer, *Capturing Museum Knowledge*, 38.

13 I. Hacking, *Representing and Intervening: Introductory Topics in the Philosophy of Natural Science* (Cambridge: Cambridge University Press, 1983); M. Lynch, "Laboratory Space and the Technological Complex: An investigation of Topical Contextures," *Science in Context* 4 (1991): 51-78.

their study of representational practices in scientific atlases, Daston and Galison identify intervention as an emerging mode of representation,[14] but only in relation to individual images. But understanding these practices is not solely a question of looking at individual jpeg files, nor of narrowly tracing a shift from photographic to digital aesthetics. The databasing and networking of these images and the role that such infrastructure plays within particular institutions are key elements in this new way of knowing.[15]

We now turn to the specific way in which images as interfaces are embedded in practices in museum settings. In order to see both the difficulties and potential of such uses of images, we focus on the skills that are needed to engage in these practices. This focus brings to the fore what people need to learn as well as what people can learn when engaging with databases of images in a multilayered, networked context. As noted, we will specifically consider a range of users of images as interfaces, inside and beyond the museum. This inclusive approach will enable us to consider practices around images as interfaces without designating them a priori as inside or outside the museum or as belonging to production or use of knowledge, opening up the possibility that these very distinctions are being reconfigured.

Skills for Interacting with Images as Interfaces

Visual material has always played an important role in archival, library, and museum documentation practices. As is the case with everyday seeing, which is developed and trained by interfering with the world around us,[16] the skills used in interaction with this visual material are also not simply there but need to be acquired and mastered. Importantly, existing practices and expertise help reshape the skills needed for visual knowing and interaction with digital images in a networked setting,[17] so that new interfaces mold and extend existing viewing habits.[18] By focusing on changing skills, we are able to show that the transformations we describe are not simply

14 L. Daston and P. Galison, *Objectivity* (New York: Zone Books, 2007).

15 S. de Rijcke and A. Beaulieu, "Networked Neuroscience: Brain Scans and Visual Knowing at the Intersection of Atlases and Databases," in *New Representations in Scientific Practice*, ed. C. Coopmans et al. (Cambridge, MA: MIT Press, 2014).

16 Hacking, *Representing and Intervening*.

17 Cf. Hand, *Making Digital Cultures*.

18 Cf. M. Alač, "Working with Brain Scans: Digital Images and Gestural Interaction in MRI Laboratory," *Social Studies of Science* 38 (2008): 483-508; L. Daston, "On Scientific Observation," Isis 1 (2008): 97-110.

a question of databases providing information more effectively through digital media as the modernization tale of computerization would have it. Rather, we are witnessing changes in the interaction with information, in the evaluation of what constitutes information, and, ultimately, in the production of knowledge. The skills needed for these new interfaces help make meaning as a result of distributed actions between users and images, actions that are not reducible to a cognitive process but are enabled – and perhaps sometimes also constrained – by the specificities and possibilities of a networked interface. A fundamental characteristic of networked practices of seeing is that the images are aligned on-screen with other digital material.[19] Therefore, viewing skills do not only alter when moving from analogue to digital imaging, but also as a result of this "windowed"[20] and networked viewing.[21] In addition, the specificities of working with/behind computer screens should also be taken into account[22] as well as the ways in which different interfaces support different kinds of interaction with the visual material.

Actively Seeing and Interacting with Visual Sources

As part of our fieldwork at the Tropenmuseum, we interviewed most of the curators on staff, each with their own area of expertise. In discussing the role of images in daily work routines, we identified skills needed to interact with the databased material. In the words of one curator:

> For the primary task of documenting and validating the collection, I absolutely need TMS ... In the past, the photographs of objects in TMS were not always of a very high resolution, which hampered the use of the zoom function, and this caused problems for some images, for instance when an entire sword is photographed, and the photographer needed to step back to capture the object in its entirety ... [T]he focus lay more on quantity instead of quality when it came to photographing the collection. In practice it turns out that you definitely need quality, otherwise you cannot properly examine the objects. The idea is that TMS facilitates

19 D. Rubinstein and K. Sluis, "A Life More Photographic – Mapping the Networked Image," *Photographies* 1 (2008): 9-28.
20 A. Friedberg, *The Virtual Window: From Alberti to Microsoft* (Cambridge, MA: MIT Press, 2006); C. Goodwin, "Seeing in Depth," *Social Studies of Science* 25 (1995): 237-74.
21 De Rijcke and Beaulieu, "Networked neuroscience."
22 Alač, "Working with Brain Scans."

scrutiny of the entire object, and that it replaces a visit to the depot. In many cases the system indeed suffices, but if a marionette, for example, is only photographed from the front, it does not work for me, because I need to see the side as well, to see the ornaments in the crown, because that gives me a clue as to which character I am dealing with.

In order to know this object visually, interaction with the zooming possibilities of digital photographs in the database is essential. The curator knows the interface and how to explore the object by changing the resolution on the screen. In some instances, these skills in interacting with elements of digital material culture prevail over the skills needed to work with the material objects themselves. These interfaces change the setting, tools, and objects with which the curators make knowledge. Yet, it is important to consider that these skills are not limited to an individual's know-how. The episode above points to the way in which the encounter with the digital image is only part of the network needed in order for skilled vision to work. Indeed, the potential of digital photography is not enough. The curator's ability to see properly, to see enough of the object, and to apprehend it in sufficiently detailed views depends on the particular instantiation of digital technology that was implemented in the institution. A "focus on quantity" which was the result of institutional priorities affects the possibilities for looking at and knowing the digital image. Institutional decisions on how to pursue digitization affect how the user is able to see and learn from an image.

In many cases, the Tropenmuseum curators worked at other ethnographic museums before coming to Amsterdam. When the curator mentioned above started working at the museum, one of his tasks was to develop a new museum section on his area of expertise. Institutional responsibilities, infrastructures, and one's particular areas of expertise all shape interactions with digital images:

Curator: "I worked at another ethnographic museum for 14 years, and knew my sub-collection by heart, which partly had to do with the fact that this was a collection of 'merely' 17,000 objects. In the Tropenmuseum, my sub-collection has three times this amount of objects ... In the beginning, I had difficulties finding out what exactly was in the collection and what I could use [for the development of the new section for which he is responsible]."
Ethnographer: "And that had to do with the amount of objects?"
C: "Yes, but it was also related to TMS ... Right now, I cannot tell the difference anymore, but back then, I felt that there was a difference in search

terms. I couldn't use the terms I was used to in my former workplace, I really needed to make a shift. For the new display I also did not want to use the most famous objects. But I did not have enough time to pull this off, so I only partly succeeded."

The curator believes that this partial success not only had to do with the contextual use of keywords, but also with the intricacies of the process of changing from analogue archiving to working with a digital image database:

C: "A number of objects are not yet photographed, or were not photographed at the time. So from time to time I now see things and think: 'Oh, this would have been something I could also have used.' But this simply has to do with the fact that we've been working through the backlog [inhaalslag] these past four years."

This exchange reveals that there are different ways of interacting with the images in the database. The predominant mode is through keywords attributed to the various objects. Such an approach is almost too banal to mention as it so fundamental to the indexing and information retrieval systems that have been central in museums for the past century. Note, however, how a different interaction with the database leads to different knowledge about the collection. "From time to time, I now see things..." points to a browsing behavior that leads to discovery, where one first sees something and then knows it. This contrasts with knowing a relevant category, name, or keyword, and then calling up the image of the object to look at it.

This example illustrates two important points about the skills deployed in the use of visual material in databases at the museum. First, digital information sources require a specific sensibility to the particularities of databases of collections; their size, the quality of images, and the way in which digitization was implemented are all elements that shape how users can interact with the visual material. These skills therefore testify to the need to learn to see in context.[23] While much of this knowledge may remain implicit in day-to-day activities, our fieldwork enabled us to make clear that when users know about the mediation of images, they are better able to see with them. The second important element illustrated by this interview is the way interfaces shape what can be known. Searching on keywords will call up certain images for further consideration, but this strategy relies on

23 Alač, "Working with Brain Scans." Goodwin, "Seeing in Depth."

a priori knowledge of relevant keywords. An interface that would support visual browsing would enable "seeing" to precede or to stimulate formalized knowledge of labels and categories.

Skills for Producing Visual Knowledge and Interacting with Platforms

In this section, we turn to the ways in which particular platforms that support visual material have come to be used at, with, and for the Tropenmuseum. The cases discussed here enable us to address the changing skills of individuals and of institutions – the former through visual "user-generated content"[24] and the latter through the interaction of the museum's collection of images with other platforms.

The Tropenmuseum is a partner of the Wikimedia Foundation, the organization behind Wikipedia and Wikimedia Commons. This cooperation developed in the context of a project called Wiki Loves Art/NL (WLANL). The initiative sought to stimulate amateur photography in museums with the goal of getting more photographs of cultural heritage on Wikipedia pages under a Creative Commons license. In June 2009, a group of forty-six museums in the Netherlands opened their doors to the public for special sessions and allowed participants to take photographs of designated objects from their collections. Participants uploaded their images on Flickr, which thus served as a conduit for the photographic material. A jury consisting of the organizers and a number of museum employees decided which photos would subsequently be used on the Wikipedia pages and who would receive an award for best photo.

In a blog post on WLANL, US-based museum exhibit designer Nina Simon noted that participating museums were especially interested in making their content digitally accessible without breaking any copyright laws, while the Wikimedia Foundation was primarily involved to obtain useful data.[25] Many photographers were more concerned with "freely making pictures for their own use (or their portfolio)" and "quite a few came to do

24 A.M. Cox, "Flickr: A Case Study of Web 2.0," *Aslib Proceedings* 60 (2008): 493-516; S.M. Petersen, *Common Banality: the Affective Character of Photo Sharing, Everyday Life and Produsage Cultures* (PhD diss., IT University of Copenhagen, 2009); N. van House, "Digital Libraries and the Practice of Trust: Networked Environmental Information," *Social Epistemology* 16 (2002): 99-114.
25 N. Simon, "Is Wikipedia Loves Art Getting 'Better'?" (2010), message posted on http://museumtwo.blogspot.com/2010/01/is-wikipedia-loves-art-getting-better.html.

their own thing and they had ample opportunity to do so,"[26] as one of the Dutch participants pointed out in reaction to Simon's post.

Clearly, multiple interests and motivations were served by this event. What is relevant for our purposes is that the circulation of images via these platforms makes possible multiple uses and appropriations – without causing them. Flickr serves as a pipeline from amateur photographers to Wikipedia, while institutional actors (Wikimedia and the Tropenmuseum) maintained a gatekeeper function. Not only do we see a shift towards the digital in the material structures that support storage and display of photographs, but in this case, both personal and institutional visual resources take the shape of networked databases. There are of course differences in the way various databases (TMS versus Flickr) are set up and in the possibilities for interaction, but we do see an alignment of the way visitors and institutions organize their visual knowledge about the museum.

Furthermore, the intersection of multiple agendas of museums and of visitors via Flickr and Wikipedia points to new ways of negotiating what it means for a digital image of a museum object to be or to become public. A photograph in this initiative was therefore treated as a creation to share with other viewers, an opportunity to document the collection, and the production of copyright-free data. The WLAN activity reconfigures the public/private dynamics around visual knowledge in interesting ways: the museum opens its doors for a "private" session for amateur photographers; amateur photographers make their personal snapshots public; and there are complex shifts in ownership, copyright, and right to publicize as the images are produced, uploaded, selected, and further circulated. The ways of working of different groups become aligned in this project; the skill of amateur photographers for producing visual knowledge about the collection is linked to the aspirations of the museum and of Wikimedia for greater production of copyright-free images, while the photographer's work is arguably enhanced through the visibility it gains in the course of this interaction. Different parties use each other to leverage a greater impact of their own skills.

Skills for Evaluating Visual Knowledge: Making Connections is Making Distinctions

We now turn to the third important part of the skills needed to engage with images as interfaces: the ability to not only understand the images, but also

26 Simon, "Wikipedia Loves Art."

to distinguish between various sources of visual information. We start by focusing on how such judgments are made in the work of registrars at the Tropenmuseum. Their job is to gather, register, classify, and document information to be put in the museum's collection database, to accompany the images in the database. We observed that in using and working with the database, registrars spend a lot of time and energy making connections. They use handbooks, Google searches (including those on image files), atlases, digital maps, classical works on countries, dictionaries, etc. They translate information on older inventory cards into the database, and they have a good memory for what is on display in the museum, currently and in the past.

In the course of their work, registrars constantly query the TMS database, using keywords related to people, geography, and objects identified on inventory cards in order to establish links ("relations") between various separate records in the database. In addition, they also regularly scan images in books so that they can also be added to the database. The information that was spread out over different locations and on different supports (inventory cards, database, printout, books, memory) can thereby be related. The creation of links is supported by the ability of the database to respond to queries and by the possibility of extending the material in the database by adding digitized files, notes, and additional keywords. But besides the potential of the database and tools, the creation of each link relies on the registrar's judgment about relevance and reliability and his or her knowledge of museum resources, both inside and outside the database. For instance, one registrar, whose area of work is the photo collection, uses his own snapshots taken on visits to Yogyakarta (Indonesia) to localize buildings and pinpoint geographical markers on historical photographs. He thus enriches the records by using his own visual material, stored on his PC, combined with his knowledge of the area.

While we witnessed the intense combination of multiple visual resources, we also noted that there are hierarchies and preferences for particular kinds of evidence and sources in making connections. We asked the registrar if he had ever considered uploading his own photographs to the museum database, and he answered that he thought this would be going too far. This example is illuminating because it reveals distinctions between visual material used as a trusted resource and material that is included in the museum collection. We have observed that images of objects or digitized photographs in the collection come to be at the center of a web of relations in the database. But the relative authority of different kinds of materials

is important; some images are "tools" (the registrar's own snapshots), and others are "material" (the images of objects or photos in the collection). While there may be an increasing tendency to make connections as a result of working in a databased setting, there are still hierarchies in the kinds of material that are worth connecting to.[27] The ability to deal with information sources is a long-standing ability for museum professionals,[28] and as this example shows, this skill is dynamic but grounded in museum traditions: it adapts to new connective possibilities of information technologies while maintaining distinctions between sources. This all points to the partial reorientation of users' skills in dealing with information sources, both inside and outside the museum. While there may be cases where images are configured to stand on their own, such as in gallery exhibitions or some forms of web-based presentation, these examples highlight the need to take users and their expectations seriously and to pay attention to the networked image as an emerging cultural logic.

Consequences for Users

Thus far, we have discussed several examples of the ways in which users encounter, use, and generate networked images of objects in museum collections. We have done so through the lens of the skills needed to interact with the images and the skills needed to produce and evaluate visual knowledge via this interaction. We now turn to the consequences of these visually mediated interfaces for users of this digital knowledge, and in particular, to the consequences for how museums view their role.

One of the corollaries of increasing uses of networked images as interfaces is a new, more distributed and connective approach to "what is the collection." This is in contrast to the more "monolithic" approach, especially visible in earlier discourses that focused mainly on "digitization," and on the museum practices that focused on registering the collection in the database as a linear process made up of discrete steps. This development is clearly visible in the case of the Tropenmuseum. The museum is cooperating with many other organizations, on a national and international level, by making the Tropenmuseum collection available on other sites via the web-based image databases and portals. Furthermore, the collection of the Tropenmuseum can increasingly be consulted via a

27 Beaulieu, de Rijcke, and van Heur, "Authority and Expertise."
28 Marty, "The Changing Nature," 83.

number of platforms besides its own website, and it is ever more connected to other databases. For example, the entire collection is accessible through the SVCN website (Stichting Volkenkundige Collectie Nederland), and part of its collection is available through the Atlas of Mutual Heritage database, an image database on the Dutch East and West India Company. The museum also participates in the Asia-Europe Museum Network (ASEMUS), and its website contains a portal to a "virtual collection of masterpieces"[29] providing access to a selection of twenty-five masterpieces from each of over sixty museums. Recently, the Tropenmuseum collection on the Netherlands Antilles and Aruba was made available via *Het Geheugen van Nederland* (the Memory of the Netherlands). This was a follow-up of an earlier cooperation involving the miniature models collection and the photo collection from Dutch East and West India expeditions. Further collaborations have been developed with Wikimedia around the history of the Maroon people of Surinam and on Indonesian culture. While the scope of these collaborations varies, some do include tens of thousands of photographs from the Tropenmuseum, which get integrated into other platforms. Because of the setup of some of these platforms, the material circulates ever more widely; Wikimedia serves as a pool from which users of Wikipedia draw to compose lemmas.

A more distributed, historically informed,[30] and connective approach to the constitution of a collection may lead to increasing opportunities for new forms of knowledge production. Building on existing practices of interactions with museum collections via web-based databases, museums are increasingly interested in using images as interfaces. As images in collection databases are part of a large amount of visual data, accessing this information requires a certain level of proficiency in collection database use and knowledge of relevant search terms. A more distributed approach to the collection allows users to see and interact with the images on platforms that are easily accessible for those accustomed to interacting with web-based encyclopaedias, search engines, and social networks. This does not leave the conception of "the collection" unchanged. The connections created on a variety of platforms further open up the collection to a much broader group of users, and it may also lead to unexpected, more associative ways in which users may access and interact with museum knowledge. Our

29 http://masterpieces.asemus.museum/index.nhn.
30 S. Legêne, "Flatirons and the Folds of History: On Archives, Cultural Heritage, and Colonial Legacies," in *Travelling Heritages: New Perspectives on Collecting, Preserving and Sharing Women's History*, ed. S.E. Wieringa (Amsterdam: Aksant Academic Publishers, 2008), 47-64.

fieldwork therefore confirmed the trend towards "post-museums" described by Hooper-Greenhill.[31] The Tropenmuseum is increasingly allowing for a diversification and distribution of museum knowledge and is becoming more inclined to let other voices speak to their collection. Our work stresses the role of networked images in this process. By linking the images to other images, to other kinds of information, and to a wider array of users, the museum supports new opportunities to co-create narratives on their collections, by both museum experts and other users.

The establishment of lateral connections to other museums and to web-based settings could also lead to increased visibility of the museum collection. This point becomes very apparent in the engagement between museums and platforms like Wikimedia Commons and Flickr. Museums have tried to make room for users within their sites, enabling functions like "my collection" as a place to "store" one's favorites or searches.

In documenting these changes, we signal a trend in which images as interfaces provide a networked context for digital knowledge, creating the conditions that can lead to interactions that exceed the limits of single images, single collections or institutions, and even of single platforms. Such changes require careful analysis and reflection on the part of museums and cultural institutions, not only in terms of their own institutional needs, but also in terms of their positioning as cultural institutions in contemporary visual culture.

Conclusion

This chapter, like the other contributions in this volume, focuses on emerging practices around collections, stressing change rather than continuity. Our material highlights the growing role of images as interfaces for both knowledge production and circulation in museums. While images are an incredibly rich site to study transformations brought about by digitization and databasing of collections, they are also useful handles to address how digital infrastructures and networks may be changing the work of museums more generally. Images are one of the several kinds of interfaces that are appearing in museums and that provide new possibilities for knowledge creation – an increasingly widespread view in museums.[32] Since digitization

31 Hooper-Greenhill, *Museums*.
32 T. Navarrete, "An Outsider's Perspective," in Beumer, *Capturing Museum Knowledge*, 69-78 (78).

is not "simply" a translation, it is crucial to consider what new possibilities are generated in the course of remediating material and embedding it in a new context. In the case of images, as they become interfaces, the dynamics of knowledge production change. We have shown in our analysis how the databased material gets connected time and again to other images, whether from print-on-paper reference books or from user-generated (holiday) snapshots.[33]

Our analysis therefore also speaks to the discussion on convergence of cultural heritage bodies.[34] The interactions between Wikipedia and the Tropenmuseum and our discussions with users point to the particularities of the visual material of the Tropenmuseum (for example, when it is spoken of as being of a higher quality, or more unique). If there is indeed convergence in terms of some functions, there seems to also be an enduring differentiation between the visual materials made available. In other words, while there may be an intensification of connection and circulation of material, the situation is not one of a "melting pot" in which differences between sources are flattened. The images of the Tropenmuseum remained distinct in the eyes of its users and even in the eyes of web-based, open-access initiatives such as Wikipedia. This is an interesting dynamic of digitization where increased intensity of connection does not mean loss of identity. Finally, the multiplication and greater circulation of images on the web do not result in the equivalence of all images. Precisely because of the co-existence and closeness of various images, it is crucial to continue our work and further investigate what enables users to determine and generate instances where images can be trusted or useful.

These observations remind us that the database, like any other sources of authoritative knowledge, is most effective when it remains in dialogue with other sources. Whether this holds across all instances of interfaces currently arising in museums is a fascinating question for further research. Innovations in museums – think of pop-up initiatives, sister museums in Europe, the US, and the Middle East, apps for social interpretation or crowd curation – all seem pointed to interaction as a core value. The new skills we noted as essential to dealing with images as interfaces may also be crucial to dealing with these developments. On the other hand, just as we stress the importance of not reifying the database and not equating it with the knowledge of the museum, interaction and diversification of publics may need to be re-anchored to the collection and material culture that are at

33 Joergensen, "Unlocking the Museum."
34 Navarrete, "An Outsider's Perspective."

the heart of museums if they are to retain their distinct value relative to other cultural institutions.

Acknowledgements

We would like to thank all our informants, at the Tropenmuseum and beyond, for their generous contributions of time, documents, and insights, and for their comments on our work.[35]

35 An article dealing with some of this material but more focused on library and information technology appeared in the journal *Library Trends*. See S. de Rijcke and A. Beaulieu, "Image as Interface: Consequences for Users of Museum Knowledge," *Library Trends* 59 (2011): 663-685.

6 Between History and Commemoration

The Digital Monument to the Jewish Community in the
Netherlands

Serge ter Braake

When the Digital Monument to the Jewish Community in the Netherlands
(from here on DM[1]) was put online in 2005, its creators took a bold step.[2] The
primary aim of this monument is to commemorate all Dutch Jewish victims
of the Second World War. The victims are listed with their full names and,
whenever possible, their address during the war, profession, pictures, and
biographical characterizations. Even before it was put online, the DM gener-
ated harsh criticism because of its supposed invasion of people's privacy.
The influential Dutch professor emeritus of cultural history Hermann von
der Dunk even called the DM a "tasteless trivialization" because it would be
placed in the online world amidst the news, commercials, and pornography.[3]

Despite the criticisms, one might argue that the DM is a project that
was bound to happen. Remembering the dead takes a prominent place
in Jewish tradition, according to which a person dies twice: once when
her spirit leaves her body and once when she is forgotten.[4] The murder of
six million Jews has understandably increased this religious and cultural
need to immortalize the dead, to ensure that their spirits somehow live
on. Additionally, memorial initiatives in general have become more wide-
spread since the First World War.[5] The advent of the Internet in the 1990s

1 http://www.joodsmonument.nl/. I was an editor for the monument between 2007 and 2012.
All URLs were last retrieved on 15 October 2014.
2 The creators of the monument were the late professor Isaac Lipschits, the International
Institute for Social History, and community builder Mediamatic LAB (in 2013 acquired by Driebit).
3 H. von der Dunk, "Een digitaal monument is een smakeloze banalisering," *Historisch
Nieuwsblad* 3 (2004), 38-39.
4 A. Margalit, *The Ethics of Memory* (Cambridge, MA: Harvard University Press, 2002), 22-23; *In
Memoriam = L'zecher* (Den Haag: SDU Uitgeverij 1995, tweede gecorrigeerde druk), v; Christopher
Bigsby, *Remembering and Imagining the Holocaust: The Chain of Memory* (Cambridge: Cambridge
University Press, 2006), 10-12, 19.
5 A. Assmann, "Re-framing Memory: Between Individual and Collective Forms of Construct-
ing the Past" in *Performing the Past: Memory, History and Identity in Modern Europe*, eds. K.
Tilmans, F. van Vree and J. Winter (Amsterdam: Amsterdam University Press, 2010), 35-50 (39);
P. Nora, "Entre Mémoire et Histoire" in *Les Lieux de mémoire, 1. La République*, ed. P. Nora (Parijs:
Gallimard, 1984), xvii, xxix; W. Frijhoff, *De mist van de geschiedenis: Over herinneren, vergeten
en het historisch geheugen van de samenleving* (Rotterdam: Vantilt, 2001), 45. Note however that

with its easy access and low-cost possibilities gave a new impulse to the remembrance of the dead.[6]

The visualization of the DM is quite ingenious. The DM opening page, sometimes mistaken for a "big block of colored dots," is the actual monument (see figure 7).[7] Every dot represents a single person. Clicking on a dot directs the user to the personal page of the victim, making it possible to switch easily between remembering all victims and individual people. The dots are grouped alphabetically by hometown, and the six different colors represent men and women from three different age groups. They are visible on both the personal and family pages.

From the outset the DM had two main objectives: "The first is to preserve the memory of Jews in the Netherlands who perished in the Shoah; the second is to enable survivors and other interested visitors to find out more about the victims of the Shoah."[8] Other objectives of the monument are the provision of educational material, stimulating research and the digitizing and preserving of historical records. In 2007 the DM officially became part of the Jewish Historical Museum in Amsterdam after its editors had already moved there from the International Institute of Social History in 2006. At the Jewish Historical Museum the goals and ambitions of the DM were further developed. To meet the demands of visitors to the monument, the community Jewish monument (from here on referred to as the Community) was put online in the course of 2010, a separate website but fully linked to the DM. It offers visitors the chance to get in touch with each other, to add their own information, and to indicate their relation (if any) to people on the DM.[9] By doing so the static nature of the monument is thrown open and the potential of the web is used more fully.

The goals of the DM are quite ambitious. There are necessarily tensions between commemoration (which often is not helped by precision and objectivity), history (which aims at being precise and objective), memory (which often claims to be precise and objective, but is not), the large set of data (that is not precise and does not claim to be so), online communication, open data, and privacy issues. The main question of this chapter therefore is: Is the DM able to achieve its goals and function as a monument and

this seems to be a general human instinct after an episode which caused many deaths, like the Dutch Revolt, and may not necessarily be a modern phenomenon.

6 P. Arthur, "Trauma Online: Public Exposure of Personal Grief and Suffering," *Traumatology* 15 (2009): 65-75.

7 http://www.joodsmonument.nl/page/552712, (FAQ, # 3).

8 http://www.joodsmonument.nl/page/274285.

9 Objectives of the Community: http://www.communityjoodsmonument.nl/page/97.

Figure 7 Screenshot from the Digital Monument to the Jewish Community

www.joodsmonument.nl. 2015

historical information provider at the same time? By looking at the history of the DM from different angles, I hope to assess the success, or lack thereof, of the DM and determine how such a monument can be designed more fruitfully in the future.

Foundation and Goals

The driving force behind the DM was Isaac Lipschits, professor of modern history at the University of Groningen (1930-2008). After his retirement he decided to try to preserve the memories of *all* Jewish victims from the Netherlands rather than "only Anne Frank."[10] His idea did not stand on its own; around the same time, several books were published to commemorate Jews who perished during the war. The idea to include more than generic information on all victims, however, was unique and would not easily find shape in book form. The publication of just the names of all Dutch Jewish victims in the book *In Memoriam* (1995), for example, took no less than

10 Television interview in *Kruispunt*, 4 May 2008; Interview with Isaac Lipschits, *Financieel Dagblad*, 19 January 2008, 13.

858 pages.[11] The possibilities were discussed with several influential Jews, and the idea of the DM was born. Lipschits himself later admitted that he hardly knew what "digitization" was at that time.[12]

In many ways the DM is more ambitious than its counterparts elsewhere in the virtual world, which usually limit themselves to the mention of the name, date and place of birth and death, and sometimes date of deportation.[13] In addition to these basic facts, the DM also endeavors to include for every person their precise address at the beginning of the war, their profession, their position in a household and institution, multiple pictures, and biographical information. As the website's own explanatory section puts it, "The basic aim is to try to show the circumstances of each individual life."[14]

The two initiatives which have most in common with the DM are the Israeli Yad Vashem memorial site[15] and the Dutch "Een naam en een gezicht" (A name and a face) project from Memorial Center Camp Westerbork. Both are, like the DM, part of a museum. The difference is that the Jewish Historical Museum is not a memorial museum/center itself but leaves that role to the affiliated *Hollandsche Schouwburg*, the former place of deportation to Westerbork for Amsterdam Jews. The Yad Vashem database aims to include all Shoah victims worldwide. However, it lacks the professional visualization of the DM and provides far less detailed information. The database from the Memorial Center Camp Westerbork cannot be consulted online and therefore remains "walled-in knowledge." Visitors can contact the memorial center for information, but an actual visit to Westerbork – in the east of

11 *In memoriam.*

12 Interview with Isaac Lipschits, *Financieel Dagblad*, 19 January 2008, 13.

13 See for example the German "Gedenkbuch": http://www.bundesarchiv.de/gedenkbuch/ directory.html, the French Memorial de la Shoah: http://bdi.memorialdelashoah.org/internet/ jsp/core/MmsGlobalSearch.jsp, and the Austrian Mauthausen Book of the Dead (Totenbuch): http://en.mauthausen-memorial.at/index_open.php. The "Een naam en een gezicht" project from Memorial Camp Westerbork is similar in its objectives, but is not available online: http://www. kampwesterbork.nl/nl/museum/archief-en-collectie/een-naam-en-een-gezicht/index.html#/ index. The Yad Vashem memorial site from Israel aims at commemorating all six million Jewish victims from the war, but it lacks a modern user interface and does not offer much room for additional information. http://www.yadvashem.org/yv/en/about/hall_of_names/what_are_pot. asp .

14 http://www.joodsmonument.nl/page/274281.

15 On Yad Vashem: Bigsby, *Remembering*, 21; O. Kenan, *Between Memory and History: The Evolution of Israeli Historiography of the Holocaust, 1945-1961* (New York: Peter Lang Publishers, 2003), xxvii, 39, 41, ch. 3. On the goals of the memorial site: http://www.yadvashem.org/yv/en/ about/hall_of_names/what_are_pot.asp.

the Netherlands while most Jews live in the west – remains the best way to access the information there.[16]

A Heterogeneous Dataset

The DM has two main goals: commemoration and information provision. Both from an academic and a commemorative point of view, the DM needs to contain accurate information if it is to be taken seriously. Reliable data on the more than 100,000 Dutch victims of the Shoah had to be assembled and entered into a database. In this section I will describe what steps were taken to achieve this and what steps were taken to further enrich the data.

When Isaac Lipschits started his work on the DM, he was amazed at how complete the archives of the war were.[17] The most important sources used for the DM are the (nearly complete) registration lists that were compiled following the Nazi order of January 1941. The lists vary slightly for every Dutch municipality, but they usually contain information per household living at one particular address. These lists were automatically matched with the names and dates of birth in *In Memoriam*, the book containing "all" names of Dutch Jewish victims of the Second World War.[18]

People who appeared on these registration lists and were listed in *In Memoriam* were given a place on the DM, using the address and profession at the time of registration. They were placed there together with the other members of their household inasmuch as the records allowed these to be reconstructed. Before it went online in 2005, the monument was tested by an expert on accuracy, who looked at the reconstruction of 100 families. The expert found a 1% inaccuracy in the way members of households were linked to each other (for example, a son listed as a husband). One and half percent of the 330 people in the sample were matched incorrectly from the registration lists to *In Memoriam*. This seemingly small error in percentage still meant that there would be thousands of mistakes in the DM in the tested categories of information alone.

16 http://www.kampwesterbork.nl/nl/museum/archief-en-collectie/een-naam-en-een-gezicht/index.html#/index. For the concept of walled in knowledge, see P. Arthur, "Exhibiting History: The Digital Future," *Recollections* 1 (2008): 33-50 (47).

17 Interview with Isaac Lipschits, *Financieel Dagblad*, 19 January 2008, 13. For this and the following three paragraphs see: http://www.joodsmonument.nl/page/274301, http://www.joodsmonument.nl/page/274122 and http://www.joodsmonument.nl/page/274287.

18 See the "verantwoording" in *In Memoriam*, xv.

It was decided that the percentage error was acceptable, and the DM was put online. Visitors to the website could fill in a form to add their own information (from memory or research), send in pictures, or point to mistakes, which was then processed by the editors of the DM. There was an unantici- pated and overwhelming response from survivors, descendants, genealogists, and (amateur) historians, and the DM was quickly flooded with thousands of messages. The editors had to check all information for accuracy, edit the text and, depending on the original message, translate it into English or Dutch. Between 2005 and 2010 around 30,000 messages were processed this way. During most of this time, the editors were three months to one year behind schedule, at times to the embarrassment of the Jewish Historical Museum.

Thanks to all the new information, the DM quickly became a database with information with a highly heterogeneous provenance and therefore trustworthiness: secondary literature like books, articles, and reference works of any kind and quality; amateur and semi-professional genealogical websites; first, second, and thirdhand memories; photographs; other memo- rial websites; interviews from the Shoah Foundation; museum objects; and archival primary sources. Such enrichments would never be possible in a traditional memorial book.

The monument and its editorial system had apparent flaws. There were, quantitatively speaking, far too many mistakes in the monument to begin with, making it a recipient of harsh criticism from families of victims, genealogists, and historians. Processing corrections to the mistakes took far too long, causing frustration ("Why is the spelling of the name of my grandfather still not corrected?") and indifference ("Why would I provide my memories if I will not live to see the results?"). Finally, most of the time it was completely unclear where information came from, with unfortu- nate consequences: genealogists feared information was stolen from their websites, family members saw new information on their ancestors' pages which they could not account for, and academics avoided the monument as an unreliable source of information.

To remedy some of these flaws, the Community was built as a separate website. This site was put into use in stages over the course of 2010.[19] All the information on the DM is also on the Community. The DM was left intact for people who prefer its simple, clean layout, and it is still used to automatically feed updates on the basic information of the victims to the Community. On the Community people can add their stories, pictures, and any other additional information themselves. Since the editors could now

19 Joods Historisch Museum, *Jaarverslagen* 2009 and 2010, 32 and 44 respectively.

concentrate on correcting the basic personal information on the DM, the website also became a more reliable source of information.

By connecting all kinds of data, quite meaningless by themselves, together in one database, the DM became a rich source of information. The question remains what role the DM plays in the *interpretation* of that information.[20] By their nature, monuments do not provide detailed contexts. The interpretation of the information on the DM, however, was partly provided by a glossary and a special topics section which were only "a few clicks away."[21] For educational purposes, one of the goals of the monument, extra material was developed for schools.[22] For more in-depth information on the persecution, however, the user is referred to the material already present in the *Hollandsche Schouwburg*, which is also part of the Jewish Historical Museum (now called the Jewish Cultural Quarter). Further context for the monument is therefore created by the institution it is embedded in.

We can conclude that at the start the DM failed as an information provider. Both from a memorial and a scholarly perspective there were too many mistakes in the data. Naturally, ten years and tens of thousands of additions and corrections later, the reliability, and therefore its potential use as a monument and a historic database, has improved. Since visitors could send in additional information, the DM's database quickly turned into a very heterogeneous dataset with information stemming from all kinds of sources. Thanks to the Community, new information can always be traced back to the person who provided it, thereby solving the unclear provenance issue.

Easy Information and Digital Commemoration

A website allows people to browse, click, search, and access more information more easily at the risk of getting a more fragmented and decontextualized picture.[23] In this section I will discuss how the digital nature of the

20 On the distinction between information and interpretation (understanding), see P. Haber, *Digital Past: Geschichtswissenschaft im digitalen Zeitalter* (München: Oldenbourg Wissenschaftsverlag, 2011), 48.

21 http://www.joodsmonument.nl/page/550153. The glossary was enriched with new entries in the course of the years. See for example; http://www.joodsmonument.nl/page/550562,(news item April 2009).

22 http://www.joodsmonument.nl/search/273990; http://www.joodsmonument.nl/search/273990; http://www.joodsmonument.nl/page/550153.

23 See C. Van Den Akker, S. Legêne, M. Van Erp, et al., "Digital Hermeneutics: Agora and the Online Understanding of Cultural Heritage", in *Proceedings of the 3rd International Conference on*

monument helped in achieving its goals of being both a source for historical research and a place for commemoration.

As seen in the previous section, the DM did not start out well as a source for historical information because of its many inaccuracies. The flood of corrections and complaints from users strongly suggested that the level of precision was deemed unacceptable by many.[24] A bigger handicap for research is that information on survivors of the Holocaust was deliberately left out due to privacy restrictions. However, since the creators of the monument at the International Institute of Social History in Amsterdam were aware of the research potential of a complete dataset, they released an "academic" and anonymized version of the database. Despite the data anonymization, the dataset was not brought online.[25] As far as I know, little research has been done with the aid of this database.[26]

Even though the DM is a visualization of only a part of the extensive database that was created, it still offers a lot of research potential. Many corrections have been made in the original database since 2005, which makes it a more reliable source for the data it *does* include than the academic release. The tens of thousands of biographical additions, added pictures, and links to other databases have highly enriched its research potential. For enhanced digital research however, the DM suffers from the fact that it is quite old. Within a few years, the DM started to suffer from having to rely on a relatively old-fashioned content management system that made work relatively slow and circuitous. Improvements cost money and when implemented always cost time to debug.[27] When in 2008 the idea was raised to link the databases of the DM and the Dutch National Committee for 4 and 5 May, all the links had to be established by hand by a volunteer, which took him over a year.[28] Manual labor also was dominant for the

Web Science (*WebSci'11*) Koblenz, Germany 14-17 June 2011, section 1. See also Arthur, "Exhibiting", 34.

24 Between 2005 and 2010 about 3.75% of the messages consisted of complaints, 22.5% of the messages were corrections (a total of more than one quarter of all messages). Roose, *Digitaal Monument*, 71. Taking an average of 350-400 messages, this means that the DM received about 100 corrections and/or complaints every month.

25 Anonieme dataset joodse gemeenschap in Nederland, 1941, IISG.

26 Ter Braake and Van Trigt used it to create some tables on the occupation of Jews in several industries: S. ter Braake and P. van Trigt, *Leerhandelaar, looier, lederfabrikant. Het success van Joodse ondernemers in de Nederlandse lederindustrie* (Amsterdam: Menasseh ben Israel Institute, 2010), 31-32.

27 http://www.joodsmonument.nl/page/550562. "In the first week of December [2009] we updated the monument to a newer version. A couple of things do not work yet as they should."

28 http://www.joodsmonument.nl/page/550562.

other projects in which documents, for example from the Jewish Historical Museum collection, were linked to the DM, or biographies written by Isaac Lipschits were added.[29]

When the Community was developed in 2009, more attention was paid to "opening up" the data for further study and browsing. Related articles would appear on the right side of the screen, and one could tag people in stories and photographs. This allowed me to write a story on the forced selling of agricultural lands during the war and tag the 400 people who appear in my database of Jews who were forced to do so during the war.[30] Through the Community, people can interact directly, ask for help, and work on projects together. In other words, the Community is what Van den Akker calls "participatory, interactive, dynamic, and collaborative, enabling direct communication."[31]

The Community still does not actively encourage the possibilities of a higher level of digital historical analysis. This has to do with both the privacy limitations and the original goals of the project. The data are not converted to "linked data" or other standardized data formats, which makes it difficult to analyze it outside its own API. It is possible to link the data on the Community to related articles on other communities built by Mediamatic, but this option was decided against to avoid "pollution." Queries can only be released on the raw data when you know how to contact the website's administrators. Privacy issues form an extra reason to "wall the data in" and protect it from the outside world – gathering systematic information on Dutch Jews on the basis of documents put together on Nazi orders can lead to both emotional and legal consequences when it is done without caution.

As mentioned above, the DM and Community are visualized in such a way that they enable the commemoration of both groups and individuals. To enhance the memorial potential of the Community, it was made an integral part of several museum projects, breaking down the digital walls. In 2010 a so-called Ikpod was developed that allows visitors to the *Hollandsche Schouwburg* to access the Community by holding the device against its memorial wall with (last) names. Since 2012 the Open Joodse Huizen (Open Jewish Houses) project runs every year around 4 and 5 May (the Dutch national days of commemoration of the dead and celebration of the liberation), which encourages people to commemorate the Jewish

29 http://www.joodsmonument.nl/page/550562 (news item April 2009).
30 http://www.communityjoodsmonument.nl/page/285975.
31 C. van den Akker, "History as Dialogue: On Online Narrativity," *BMGN/Low Countries Historical Review* 128, no. 4 (2013): 103-117 (103).

victims in smaller groups in the houses where they lived before deportation. People are also encouraged to hang posters in their windows, stating what Jews were deported from there during the war. With a Jewish Houses app (for smartphones), people can see where in their street/neighborhood Jewish people lived who were deported and killed during the war.[32] In these ways the analogous archival data which was translated into a digital visualization becomes physical again.

To summarize, the DM is a project that originally was limited to digitizing available historical records and aggregating them into one website visualized as a monument. For quantitative analyses an anonymized database is available on request. The web 2.0 applications of the Community allows for the coexistence of research and commemoration. The possibilities for high-level historical analysis are limited however. For commemoration the DM offers an alternative to a physical monument. People who prefer to commemorate the dead individually in their own time can find most characteristics of a physical monument on the DM.

Between History and Memory

The DM combines a wide variety of information from memories and historical records. Often, however, memory and history present us with different and opposing information. In this section I shall describe how the DM deals with these possible discrepancies and what that means for the DM as a place of commemoration and research.

Memory is notoriously unreliable since people (unknowingly) reshape their memories based on later knowledge or events. This is especially true when the memory is about events that traumatized people.[33] That being said, at times the historian has no other choice than to rely on memories. Furthermore, the way people experienced historical events is now considered to be a valuable addition to the historical record. Later testimonies rarely add to our factual knowledge, but they do give insight into what

32 D. Duindam, "Stilstaan bij de Jodenvervolging. De Hollandsche Schouwburg als plek van herinnering," in *De Hollandsche Schouwburg: Theater. Deportatieplaats. Plek van herinnering*, eds. F. van Vree, H. Berg, and D. Duindam (Amsterdam 2013), 218-245 (245). http://www.communityjoodsmonument.nl/page/297976; http://www.communityjoodsmonument.nl/page/334671; http://www.communityjoodsmonument.nl/page/324420.

33 E.g. Bigsby, *Remembering*, 10-12, 19; Frijhoff, *Mist van de geschiedenis*, 67; Kenan, *Between Memory and History*, 21.

events meant for the people who lived through them.[34] Commemoration often aims to reaffirm one's identity, while academic history is mostly concerned with historical accuracy. When these goals clash, emotionally charged debates may follow.[35]

It is difficult to study memory and history as independent from each other since they are often intertwined. Personal memories are tainted by knowledge acquired afterwards, as written down in history books or narrated in documentaries, and by the collective memory of an event.[36] History in turn runs the risk of shaping itself around the ideas imprinted in collective memory. This phenomenon is especially clear when studying the history of the Holocaust.[37] There are plenty of examples of survivors of the Holocaust who model their memories on historical accounts. In the Netherlands, for instance, the standard works of Jacques Presser and Louis de Jong have become part of the "collective memory," distorting the memories of individuals.[38] Historiography, on the other hand, also models itself on collective memories.[39] Historical interpretations that disagree with such collective memories may lead to emotionally charged polemics.[40] Without going deeper into the detailed discussions on the role of memory in history, we can conclude that there is an undeniable interplay between memory and history.[41]

34 A. Assmann, "History, Memory, and the Genre of Testimony," *Poetics Today* 27 no. 2 (Summer 2006): 261-273 (261-263).

35 Nora, "Entre Mémoire", xix-xx; M. Rothberg, *Multidirectional Memory: Remembering the Holocaust in the Age of Decolonization* (Stanford: Stanford University Press, 2009) 2-3, 13.

36 The term collective memory was made famous by M. Halbwachs, *Das Kollektive Gedächtnis* (Frankfurt am Main, 1991).

37 Bigsby, *Remembering*, 10-12, 19; S. Hogervorst, "De enige informatiebron is onze herinnering; Geschiedschrijving over Ravensbrück door overlevenden en anderen," *Biografie Bulletin* 21 no. 2 (2011), 50-57 (50-51); B. Siertsema, "Kampgetuigenissen: Herinnering in teksten," in *De dynamiek van de herinnering. Nederland en de Tweede Wereldoorlog in een internationale context*, eds. F. van Vree and R. van der Laarse (Amsterdam 2009), 106-127. It also is striking to note that prominent figures from history like Anne Frank and Adolf Hitler are mentioned in memories more often than could be expected or historically supported. See for an unlikely example of both: *USC Shoah Foundation*, USC-SF nr. 21178 (interview Marion Adler).

38 F. van Vree, *In de schaduw van Auschwitz: herinneringen, beelden, geschiedenis* (Groningen: Historische Uitgeverij, 1995), 14, 103-104.

39 Kenan, *Between Memory and History*, xiv-xv.

40 E.g. B. van der Boom, "Wij weten niets van hun lot: gewone Nederlanders en de Holocaust" (Amsterdam: Boom, 2012), 427. See also Van der Boom's blog: http://wijwetennietsvanhunlot. blogspot.nl/.

41 The academic writing on collective (or collected, common, or shared) memory is massive and beyond the scope of this article to deal with in such a manner as to do justice to the observations of many leading philosophers and theorists. The observation of an undeniable interplay between

As we have seen previously, the DM offers people the opportunity to add their own, or secondhand, memories to the database. The question here is how the DM deals with the interplay of and friction between history and memory. The DM is a virtual place where different memories come together; it therefore is a place of *collected memory*.[42] A wide variety of people contribute to this mnemonic community, both from Jewish and non-Jewish origins and from all parts of the world.[43] We have already seen, however, that in the beginning, participating in this mnemonic community was limited for several reasons; most importantly, all information had to be checked for accuracy by the editors. With the core data, this was not as problematic as with the personal memories. It is usually possible to check the spelling of a person's name, the date of birth, or place of residence, but it is rarely possible to check if someone had red hair,[44] often wore a white skirt,[45] or was an outstanding football player.[46] The editors were instructed to use common sense to determine whether information was reliable or not, especially by taking into account what relation the information provider had to the deceased.[47]

The editors' interference with memories inevitably meant taking something away from the memory. First of all, the editors intervened with the language used. Spelling and grammar were corrected, and excessively emotional language (like "dirty krauts") was rephrased. Incoherent and too lengthy contributions were rewritten and shortened. Things that were highly unlikely or obviously incorrect were corrected (like a year of deportation) or left out. References to people who survived the war were anonymized in accordance with the data protection laws. For the same

memory (in any form) and history is sufficient for the analysis here. For further reading, see for example: Margalit, *Ethics of Memory*, 50-52; Rothberg, *Multidirectional Memory*, 14-15; W. Kansteiner, "Finding Meaning in Memory: A Methodological Critique of Collective Memory Studies," *History and Memory* 41 (2002), 179-197, (189, 197).

42 On the difference between collected and collective memory, see for example Arthur, "Trauma Online," 71.

43 In 2008 the Digital Monument received not only more than 143,000 visits from the Netherlands, but also over 9,000 from the United States, more than 5,000 from both Israel and Germany, over 4,000 from Belgium, nearly 3,000 from the United Kingdom, nearly 2,000 from Canada, over 1,300 from France, and 1,000 from Australia. Fewer visitors came from countries in South America. Joods Historisch Museum, Monument statistiek 2008.pdf (9 January 2008-8 January 2009).

44 Bertha Philips: http://www.joodsmonument.nl/person/320145.

45 Natje Hijmans-Hangjas: http://www.joodsmonument.nl/person/458526.

46 Hartog van Rhyn: http://www.joodsmonument.nl/person/451595.

47 Joods Historisch Museum, Protocol voor het aanbrengen van aanvullingen en correcties bij het Digitaal Monument Joodse Gemeenschap in Nederland (Maart 2009), 6.

reason the gender of surviving children was anonymized. To guarantee the privacy of the contributors, all additions were placed anonymously. This resulted in many biographical contributions having "addition of a visitor to the website" as its provenance information.[48]

No matter how understandable the editing process was at the time, it caused some serious problems for the monument and its function as a mnemonic community. Firstly, the anonymization of the contributions made the provenance information quite useless. If there is no way of knowing who provided the information, there is also no way of assessing whether he or she is a reliable witness and of interest for follow up contact. Understandably there were many requests from third parties to get in touch with the person who provided information or a picture.[49]

Secondly, the editorial process was an attempt to transform memories into accurate representations of the past, while memories are valuable precisely because they are personal and may differ from the generally accepted historical account. Thirdly, conflicts over the contents on the website could arise; often memories conflict and what should the editors do when such memories are provided? Place them both or choose the most likely version? Or in other words, give preference to the monument as a place of collected memory or as a historical information provider? What if either choice hinders people in commemorating the dead? As far as I know, no policy regarding these issues was ever made. Fourth, the editing of biographical information took a lot of time. From a sample of 320 messages between 2005 and 2010, Rose calculated that about 36% contained additional biographical information.[50] Finally, and perhaps most importantly, many contributions were not placed on the monument because they did not contain any information that could be used; more than one third contained information on the visitor him/herself (e.g. "I am one of four surviving grandchildren"), a request for information, a request for contact, the offering of help, or the offering of goods.[51] All these messages were treated as useless for the DM.

The editorial system therefore hindered the role of the DM as an instrument for research and especially in its function as a place of commemoration.

48 Joods Historisch Museum, Protocol voor het aanbrengen van aanvullingen en correcties bij het Digitaal Monument Joodse Gemeenschap in Nederland (Maart 2009) 6.

49 Two of the standard sentences from the editors of the monument were created to answer such requests: Joods Historisch Museum, Digitaal Monument, standaard zinnen.doc (version 25 mei 2010).

50 F. Roose, *Het Digitaal Monument Joodse Gemeenschap in Nederland. Een onderzoek naar de Joodse herinneringsgemeenschap*, (master thesis Radboud Universiteit Nijmegen, 2012), 71.

51 Roose, *Digitaal Monument*, 71.

Once again, the Community took away many of the identified limitations. On the Community, people can create an account and add information and pictures themselves, even about themselves, without the interference of the editors. Because people can immediately see who made a certain contribution and how to contact the person, the Community is a worldwide mnemonic community where collected memory shapes the image of the past. Conflicting memories, and memory conflicting with history, can now be made visible.[52]

In conclusion, we can say that from a historic, mnemonic, and commemorative point of view, the DM fell short in its first years. Not only was the information not reliable enough, as we saw, but there also was not enough room to correct this information quickly, to add one's own memories uncensored, and to see what memories belonged to whom to assess its reliability. It also was not clear whether the DM would give precedence to historical accuracy or personal memories. The Community solved the issues of provenance of the information and enabled people to add their own information directly and uncensored. The members of the Community became directly responsible for their input, rather than the editors of the DM.

Conclusion

In this chapter I discussed the Digital Monument to the Jewish Community in the Netherlands (DM) as a virtual place for commemoration, as a provider of historic information, and as a digital project. I have tried to assess how successful the DM was as a digital project in achieving its at times difficult to reconcile objectives: commemoration (which is often not helped by precision and objectivity), academic history (which has to be precise and objective), memory (which often claims to be precise and objective but is not), the analysis of large sets of data (which is not precise and does not claim to be so), online communication, open data and privacy issues – all had to be dealt with. By analyzing the monument from these different angles, I hoped to find an answer to the question if it is possible to combine these objectives successfully and how similar projects can be designed in the best possible manner in the future.

First, there is the DM as a digital project. We can conclude that it succeeded in digitally bringing together a wide variety of analogous sources.

52 See also Arthur, "Trauma Online," 69.

Privacy issues, however, prevented the DM from including information on survivors of the Holocaust. Furthermore there are, understandably, no tools for academic analysis of the data on the DM since that would diminish its memorial function. Still, web 2.0 technologies were used for the Community to open up a dialogue among the visitors of the monument, to share stories and experiences, and to provide the provenance of new information.

Regarding the DM as a source of historic information, we can conclude that it succeeded in bringing together heterogeneous data, connecting them in a clever way, and providing a visualization that enables easy access for both the lay and the professional user. We also need to conclude, however, that the error margin was too high when the DM was put online in 2005. Additional biographical information came from all kinds of sources, but personal memories were all anonymized, making it very difficult (and only with a tortuous intervention from the editors) to trace the provenance information. Only when the Community was put online in the course of 2010 were the provenance issues resolved. The DM also became a more reliable source of information, after years of manually processing corrections.

Since many additions to the DM were memories (not necessarily first-hand), we can also speak of the DM as a source of *collected* memory. In turn this aggregation of memories feeds back into the *collective* memory of people about the Holocaust. The DM binds together an "artificial mnemonic community" of people worldwide from all kinds of religions and backgrounds who wish to commemorate or study the Holocaust.

There also is the question of whether the DM and Community are digital places for *commemoration*. This question cannot be answered easily since people commemorate in individual ways, which makes it hard to determine whether someone actually uses the DM to commemorate the dead. With its editorial system, the DM leans more towards historic objectivity than the Community, which allows the addition of all kinds of memories, interpretations, and links. For people who believe that the information on the dead should be restricted – some think the name alone suffices – the DM is the best choice for commemoration.

The DM opens new possibilities for switching easily between commemorating all Jewish victims in a general visualized monument and commemorating individuals with their own photos, address, personal, and biographical information. The question remains if a non-physical monument viewed on a technical device can evoke the same feeling as a physical monument where thousands of people gather. The large numbers of visitors and additions are an indication of success but in themselves do not justify the DM as a monument since it does not follow automatically that the DM

is used as a place of commemoration. Several museum projects link the DM to the outside world though, like to the wall of names in the Hollandsche Schouwburg, which also makes it part of the offline memorial culture.

The DM was subject to harsh criticism even before it was put online. What did it do to mute these criticisms? In the beginning it was not well received; there were too many mistakes, the number of additions it received was far higher than estimated, the editorial process was too slow, and the provenance of the added information unclear. As a consequence it was neither taken completely serious as an information provider nor as a monument, since accuracy is one of the requirements for both academic research and commemoration. A lot of time (years), effort, and money were put into manually correcting the information on the DM. There was also a tension between history, memory, and commemoration that could not be smoothed over with the interface and policies at that time. The online options for an environment of dialogue were not tapped into yet and the question is if that would have been feasible back in 2005. The creation of the Community in 2009 helped to overcome most problems; dialogue was enabled, different memories and historical research could coexist, group projects were facilitated, and memories could be placed without interference or editing.

So what does this teach us about digital projects of this size and nature? First of all, projects this large, especially when they are dealing with a painful subject, should not be put online before they are accurate enough to pass the tests of critical users. It is of course difficult to know when this is the case, but when simple calculations based on error percentages show that there are thousands of mistakes, most projects are not good enough yet. A lot could be gained in the communication with the outside world by presenting a project as a work in progress. Furthermore, it is important to find a balance between what should be kept in the hands of the professionals and what should not. For the sake of uncensored exchange and interactivity between users and to cut down on manpower expenses, a lot can be said for leaving most to the users themselves.

7 From the Smithsonian's MacFarlane Collection to Inuvialuit Living History

Kate Hennessy

Digital technologies are providing heritage institutions with a range of possibilities for sharing curatorial and ethnographic authority with communities of origin. In recent years, a number of digital projects have demonstrated the potential for museum digitization initiatives to connect tangible and intangible cultural collections to indigenous peoples – in particular, opening up discussions of the opportunities and challenges associated with "digital repatriation," the return of heritage documentation in digital form to communities of origin[1] (see figure 8). In these projects, technical experimentation and innovation intersect with diverse cultural contexts and protocols, research ethics, and approaches to ownership of cultural property. For example, the Mukurtu Content Management System and the Plateau Peoples' Portal have demonstrated possibilities for integrating digital cultural objects into archives that respect and support existing cultural traditions and practices by replicating dynamic protocols for access and circulation of cultural knowledge.[2] These protocols, digitally encoded through long-term collaborative design and production, have challenged the default of open access in favor of local control over sensitive cultural heritage.[3] In another research collaboration between the Cambridge Museum of Archaeology and Anthropology and the A:shiwi A:wan Museum and Heritage Center of Zuni, digital collections were made available for reconnection to narrative and other forms of intangible knowledge, while demonstrating the extent to which institutional ideologies and practices had previously excluded Native American interpretations of their material

1 K. Hennessy, "Virtual Repatriation and Digital Cultural Heritage: The Ethics of Managing Online Collections," *Anthropology News* 50 no. 4 (2009): 5-6; P. Resta, et al., "Digital Repatriation: Virtual Museum Partnerships with Indigenous Peoples," in *Proceedings of the International Conference on Computers in Education: IEEE Computer Society* (2002); T.B. Powell, "Digital Repatriation in the Field of Indigenous Anthropology," *Anthropology News* 52 no. 7 (2011): 39-40.
2 K. Christen, "Opening Archives: Respectful Repatriation," *American Archivist* 74 (2011): 185-210.
3 K. Christen, "Access and Accountability: The Ecology of Information Sharing in the Digital Age," *Anthropology News* 50 no. 4 (2009): 4-5.

culture.[4] GRASAC, the Great Lakes Alliance for the Study of Aboriginal Arts and Culture, was created with the goal of determining if it would be "possible to use information technology to digitally reunite Great Lakes heritage that is currently scattered across museums and archives in North America and Europe with Aboriginal community knowledge, memory, and perspectives,"[5] suggesting possibilities for the generation of new cultural knowledge by reuniting fragmented Aboriginal collections. My previous work with the Doig River First Nation in British Columbia on the virtual museum exhibit *Dane Wajich – Dane-ẓaa Stories and Songs: Dreamers and the Land* has shown that while the digitization and return of cultural documentation to communities of origin can facilitate self-representation and the articulation of local cultural property rights, digitization and circulation can make it virtually impossible to enforce those rights.[6]

With the initiation of these projects and an exponential number in production and being planned for years to come, new sites for the ethnography of digital cultural production have emerged at both institutional and community scales. In this chapter, I ground a preliminary exploration of the effects of digitization and virtual repatriation in the Reciprocal Research Network (RRN), an on-line museum portal that has been co-developed by the Museum of Anthropology at the University of British Columbia in collaboration with three Northwest coast First Nations – the Musqueam Indian Band, the U'Mista Cultural Society, the Stó:lō Nation/Stó:lō Tribal Council – and more than twenty-five international museum institutions that have made their Northwest coast collections data available in a single online archive. The RRN represents a significant site from which to trace the evolution of digitally mediated research relationships, reconnections of museum collections to originating communities, and the development of reciprocal research and curatorial initiatives between museums and stakeholder communities. How do new media practices shift the balance between institutional expertise and Aboriginal participation in the representation of their cultural heritage? How are existing systems of ownership, copyright, and intellectual property rights challenged as originating communities gain better knowledge of their cultural property in museum collections? How are

4 R. Srinivasan et al., "Diverse Knowledges and Contact Zones within the Digital Museum," *Science, Technology, & Human Values* 35 no. 5 (2010): 735-768.

5 GRASAC (2011) https://grasac.org/gks/gks_about.php. Last accessed 9 January 2014.

6 K. Hennessy, "Virtual Repatriation and Digital Cultural Heritage: The Ethics of Managing Online Collections," *Anthropology News* 50 no. 4 (2009): 5-6; A. Ridington and K. Hennessy, "Building Indigenous Agency Through Web-Based Exhibition: Dane-Wajich – "Dane-zaa Stories and Songs: Dreamers and the Land," in *Museums and the Web: Proceedings 2008*.

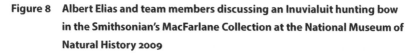

Figure 8 Albert Elias and team members discussing an Inuvialuit hunting bow in the Smithsonian's MacFarlane Collection at the National Museum of Natural History 2009

Photo by Kate Hennessy

these technologies able to accommodate and reflect indigenous protocols for the management and circulation of cultural knowledge?

I begin to answer these questions by describing elements of a virtual museum exhibit created by the Inuvialuit Cultural Resource Centre in Inuvik, Northwest Territories, Canada, and collaborating researchers, curators, and media producers (myself included).[7] This project, *Inuvialuit Pitqusiit Inuuniarutait: Inuvialuit Living History,* used the RRN's Application Programming Interface (API) to curate and remediate object records from the Smithsonian National Museum of Natural History's MacFarlane Collection – which originated in the Anderson River region in Inuvialuit territory – and to reconnect the collection to intangible knowledge, local cultural practices, and revitalization initiatives.[8] Through the lens of this

7 For a detailed description of the project from its inception to the Spring of 2011, see N. Lyons, K. Hennessy, C. Arnold, and M. Joe, *The Inuvialuit Smithsonian Project: Winter 2009-Spring 2011* (2011). Unpublished Report to Canadian Heritage, Inuvialuit Regional Corporation, and Simon Fraser University's Intellectual Property Issues in Cultural Heritage (IPinCH) Project.

8 *Inuvialuit Pitqusiit Inuuniarutait*: Inuvialuit Living History. http://inuvialuitlivinghistory. ca/. Last accessed 9 January 2014.

project, I investigate museum collections' digitization and virtual exhibit design practices as productive locations for the ethnography of Aboriginal and institutional cultural production. I suggest that digital practices in museums and originating communities are opening spaces, both online and offline, for the practice of collaborative research that illuminates wider relations of power embedded in ethnographic and curatorial practices and digital technologies.[9]

The Reciprocal Research Network

The Reciprocal Research Network's home page[10] features a welcome in three First Nations languages – *Hən̓q̓əmin̓əm̓, Halq'eméylem, and Kwak̓wala – representing the languages of the project's co-developers,* the Musqueam Indian Band, the U'Mista Cultural Society, the Stó:lō Nation / Stó:lō Tribal Council. In January 2012, the RRN listed access to over 400,000 objects from a growing number of holding institutions, including the First Nations co-developers. These digital object records are available to registered users through a faceted search interface, which at the highest level starts with What, Who, Where, and When, and then drills down into increasingly specific categories of objects such as culture, place collected, material, manufacturing technique, and many more. Users can create their own collections, virtually dropping them into a metaphorical Northwest coast bentwood box, invite collaboration and conversation from other researchers and holding institutions, and attach media and information to object records.[11]

The RRN's home page includes a link to its API (Application Programming Interface). This API is essentially a set of encoded rules and data that gives developers access to digital collections records on the RRN, which enables developers to remediate institutional collections data in new works,

9 Natasha Lyons has articulately explored our team's strategy for "creating space" for collaborative research engagement in Lyons. See "Creating Space for Negotiating the Nature and Outcomes of Collaborative Research Projects with Aboriginal Communities," *Inuit Studies Special Issue on Intellectual Property and Ethics* 35 no. 1-2 (2011): 83-105.

10 http://www.rrncommunity.org/.

11 L. Iverson, S. Rowley, L. Sparrow, D. Schaepe, A. Sanborn, R. Wallace, N. Jakobsen, U. Radermacher, "The Reciprocal Research Network," in *Museums and the Web: Proceedings 2008*; S. Rowley, D. Schaepe, L. Sparow, A. Sanborn, U. Radermacher, R. Wallace, N. Jakobsen, H. Turner, S. Sadofsky, and T. Goffman, "Building an On-Line Research Community: The Reciprocal Research Network," in *Museums and the Web: Proceedings 2010*.

virtual exhibits, or as XML feeds. While the API facilitates a new degree of public access to collections, it also represents an opportunity for originating communities to re-contextualize their cultural heritage in museums in new digital forms, potentially shifting power over representation from institution to Aboriginal publics. According to project lead Sue Rowley,

> Our goal was to develop a new research tool for accessing information housed in geographically dispersed locales as well as providing net-working functions for effective engagement and collaboration among researchers with diverse backgrounds. Most significantly, the creation of this virtual research space emerged from the desire of all participants to base the project on the principles of respect for the originating communities' different knowledge and value systems as well as for the partner museums.[12]

In keeping with these intentions, the RRN homepage also displays a vi-brant blue, black, and white logo designed by Terry Point, a member of the Musqueam Indian Band, and William Wasden Jr., a member of the 'Na̱mg̱is tribe of the Kwakwa̱ka̱'wakw First Nations. The logo depicts dynamic elements of salmon, killer whale, human beings, and a canoe. The RRN website further describes how Point and Wasden, both RRN interns between 2004 and 2005, developed the logo considering traditional naviga-tion and creation themes, and relating ideas of communication and renewal of knowledge to the function of the RRN:

> Umeł, Chief of the Ancients Raven, needs to be treated carefully, because he is the all-present trickster. He has human qualities and is able to transform himself into a man; the figure in the beak represents that ability. The dorsal fin of a killer whale is depicted by the Raven's beak with a stylized ovoid hole in it. The front seat of a sea hunter's canoe will have a hole carved in it and when the hunter dies, the seat will become his dorsal fin when he transforms into a killer whale. The human face in the beak represents the raven's human qualities as he is able to transform between forms and also connects to the sea hunter. He holds the messen-ger canoe in his mouth, upside down. This refers to people saving young salmon caught in a river with low water levels by placing them in a canoe and dumping them into another river, the salmon would survive and colonize the new stream. In the centre of the canoe is a box of treasures,

12 Rowley et al., "Building an On-Line Research Community," 15.

representing the knowledge being returned to the communities through the RRN. The salmon in the logo are wild, indicated by the presence of the adipose fins; the male is depicted above the female as if in spawning position and both their tailfins continue as negative space along the design of the raven. There are four stars with four points each, because four is a sacred number in Kwakwa̱ ka̱ 'wakw cultural beliefs. The colour is Reckitt's Blue – a laundry blueing agent introduced to the Northwest Coast and quickly adopted as a paint. William has observed that this particular blue shade is used in art around the world and seems to have close representational associations with the supernatural.[13]

Supernatural agents of transformation – raven, the trickster; the sea hunter's canoe; the human being – are presented as metaphors for digital transformations integral to the function of the RRN. As tangible cultural objects in museum collections are digitally documented and circulated over the Internet, they take on new significance and consequence as digital objects with unlimited potential to be replicated and shared. Like the salmon rescued from thirsty rivers and introduced to new streams to propagate, colonizing new territory, so the digital objects being produced by the RRN partnering institutions and Indigenous co-developers constitute new flows of information populating diverse online spaces. Reckitt's blue, adopted by Northwest coast peoples as a paint, alludes to the ongoing Indigenous re-purposing of colonial technologies for specific cultural and artistic innovation, a dynamic that may be at play in the development of the RRN itself. The logo's representation of the box of treasures, finally, finds its digital counterpart in the RRN's servers, processors, and data storage, which have been structured to support the reciprocal sharing of knowledge among researchers, members of originating communities, students, and museum institutions.

Can the Reciprocal Research Network possibly deliver on the promise suggested by its logo? Or is the RRN one of many emerging "asymmetric spaces of appropriation"[14] being developed in the name of collaboration and repatriation? Does the project merely replicate anthropology's salvage paradigm in digital form, hungrily seeking additional cultural data to enhance institutional collections without giving in return? Or might technical experimentation and innovation, the forging of new partnerships, and

13 Reciprocal Research Network. (2011). http://www.rrncommunity.org/pages/about. Last accessed 22 October 2015.
14 Robin Boast, "Neocolonial Collaboration: Museum as Contact Zone Revisited", *Museum Anthropology* 34 no. 1 (2011), 56-70 (63).

collaborative media production facilitate the kind of reciprocal research initiatives that the RRN was built to create? The RRN is a promising starting point and space of interaction in its own right, but certainly not an end in itself; rather, as I suggest below, the RRN might also be understood as a tool for Aboriginal self-representation and reclamation of ethnographic authority, a process that "requires that museums learn to let go of their resources, even at times of the objects, for the benefit of the use of communities and agendas far beyond its knowledge and control."[15]

The Inuvialuit Smithsonian Project: Beginnings

In the fall of 2009 I travelled with an Inuvialuit delegation from the Western Arctic and a team of filmmakers, archaeologists, and educators to view the MacFarlane Collection at the Smithsonian's National Museum of Natural History.[16] We spent a week examining, handling, discussing, and documenting this collection of ancestral objects, aware that this was the first time that Inuvialuit peoples had come into contact with them since they had been sold to Roderick MacFarlane at a Hudson's Bay Trading Post at Fort Anderson 150 years earlier. At the same time that our project team was considering how to best facilitate greater Inuvialuit access to this remarkable collection, the Smithsonian Institution was working to make a selection of its digital collections available online through the Reciprocal Research Network. We proposed that the Smithsonian make the MacFarlane Collection available through the RRN. We then asked them to give our team permission to re-mediate their digital collections data to create our own representation of the MacFarlane Collection in the form of a virtual exhibit, and we have been collaboratively developing and populating this website since then.[17]

In the context of the collaborative production of the *Inuvialuit Living History* project, our team has been engaging with a range of themes and

15 Boast, "Neocolonial Collaboration," 67.
16 The delegation to the Smithsonian's National Museum of Natural History included, from the North: James Pokiak, Albert Elias, and Helen Gruben (Inuvialuit Elders); Karis Gruben and Shayne Cockney (Inuvialuit youth); Freda Raddi (a seamstress); Brett Purdy, Dave Stewart, and Maia Lepage (documentary producers from the Inuvialuit Communications Society); and, two trip organizers – Cathy Cockney, Manager of the Inuvialuit Cultural Resource Centre, and Mervin Joe, from Parks Canada, Inuvik. From the South, our team included: Natasha Lyons (Ursus Heritage Consulting, project director), Charles Arnold (University of Calgary), Kate Hennessy (Simon Fraser University), and Stephen Loring (Smithsonian Institution, Arctic Studies Center).
17 Lyons et al., *The Inuvialuit Smithsonian Project.*

practices, generating new knowledge of Inuvialuit material culture and digital platforms for representing it. Broadly, we have been questioning the idea of digitization and circulation as virtual repatriation[18] and experimenting with the creation of alternative representations of tangible and intangible cultural heritage; we have been exploring institutional and culture-specific development of digital information systems and practices, including systems of ownership of traditional knowledge and collectively owned cultural expression; and we have been engaged in collaborative media production and exploring the possibility of reciprocal research and curation in digital environments.[19] While a full discussion of these collaborative explorations is beyond the scope of this chapter, I focus here on several key aspects of *Inuvialuit Living History*, still a work in progress: namely, our re-framing of the presentation of institutional collections data, relationships between media objects, and systems of indicating ownership of digital cultural property. These elements highlight tangible and digital collections as significant documents of dynamic relationships and collaborations, bearing the traces of shifting technical, curatorial, ethical, and disciplinary practices. They also foreground digital museum collections and their re-contextualization by originating communities as significant locations in which ethnographic authority is being relinquished by museums in support of, in this case, Aboriginal self-representation.

From the MacFarlane Collection to *Inuvialuit Living History*

Roderick MacFarlane was a Hudson's Bay Company trader who established Fort Anderson on the Anderson River in the Mackenzie Delta in 1861. It was the first post in the Northwest Territories aimed at trading with the Inuvialuit, but it was abandoned in 1866 because of the difficulty of the overland supply route and the first disease epidemic that ravaged the region.[20] While serving at Fort Anderson, MacFarlane was recruited by Robert Kennicott, an agent of the Smithsonian Institution,

18 Kate Hennessy, "Virtual Repatriation."
19 See Christen, "Opening Archives"; Rowley et al., "Building an On-Line Research Community"; and R. Srinivasan, "Indigenous, Ethnic, and Cultural Articulations of New Media," *International Journal of Cultural Studies*, 9 no. 4 (2006): 497-518, for analyses of digital humanities initiatives that have explored these dynamics and their technical applications in the context of Indigenous cultural knowledge and digital heritage.
20 D. Morrison, "Painted Wooden Plaques from the MacFarlane Collection: The Earliest Inuvialuit Graphic Art," *Arctic* 59 no. 4 (2006): 351-360.

Figure 9 Handwritten label in the MacFarlane Collection 2009

Photo by Kate Hennessy

to collect natural and cultural history specimens for the museum. The MacFarlane Collection came to include approximately 5,000 objects, including hundreds of ethnographic items such as skin clothing, hunting tools, pipes, adornments, and graphic arts, as well as thousands of natural history specimens such as the skeletons and skins of both birds and animals, and dozens and dozens of bird eggs. The majority of these objects went to the National Museum of Natural History in Washington, DC, while some were donated to the McCord Museum (then the Natural History Society in Montréal, Canada) and the National Museums of Scotland (then the Edinburgh Museum of Science and Art).[21] A small number of the MacFarlane collected objects that came to the Smithsonian were later exchanged with other institutions principally in Chicago and Copenhagen. The recent digitization of the Smithsonian's collection, as well as similar initiatives at institutions like the McCord Museum, make eventual reunification of the fragmented collection a distinct possibility (see figure 9).

The MacFarlane Collection is arguably the most significant assemblage of Inuvialuit ethnographic artefacts, but it has never been exhibited in its

21 Morrison, "Painted Wooden Plaques."

entirety. In the course of the *Inuvialuit Living History* project, it has become clear to our team that the MacFarlane Collection has great importance to contemporary Inuvialuit peoples, who are actively engaged in building educational resources for Inuvialuit communities and representing Inuvialuit culture and language to local, national, and international audiences (the long-term film production activities of the Inuvialuit Communications Society, and the cultural revitalization activities of the Inuvialuit Cultural Resource Centre being central examples). While the collection had been partially photographed and digital catalogue information was available on the National Museum of Natural History's website, the collection had remained largely inaccessible to Inuvialuit peoples, separated by great distance and unfamiliarity with the Smithsonian's online catalogue. Available online catalogue information communicated what little was known about the objects and organized the collection using generalist regional identifiers such as "Northwest Territories, Canada" and outdated categories such as "Eskimo" or "Esquimaux."

In November of 2009, our delegation spent five days in the collections storage facility at the Smithsonian's Museum Support Center with curator and project partner Stephen Loring. Trays containing Inuvialuit articles of clothing, hunting tools, artwork, and natural history specimens were carried out of their places in storage, and the objects were carefully handled, inspected, discussed, and documented by members of the delegation. These moments of exploration were charged with excitement, as Inuvialuit peoples were able to physically access the objects for the first time since their collection by Roderick MacFarlane a century and a half before. Recognition of the responsibility of museums to make their collections accessible to descendant community interests has been a defining component of the Smithsonian's Arctic Studies Center since its inception.[22] As well illustrated in Ann Feinup-Riordan's explorations of artefacts with Yup'ik elders in the

22 S.S. Loring, "Repatriation and Community Anthropology: the Smithsonian Institution's Arctic Studies Center," in *The Future of the Past: Archaeologists, Native Americans, and Repatriation*, ed. T. Bray (New York: Garland, 2001), 185-200; Loring, "From Tent to Trading Post and Back Again: Smithsonian Anthropology in Nunavut, Nunavik, Nitassinan, and Nunatsiavut – the Changing IPY Agenda, 1882-2007," in *Smithsonian at the Poles: Contributions to International Polar Science*, ed. I. Krupnik et al. (Washington: Smithsonian Institution Scholarly Press, 2009), 115-128; Loring, "Foreword," in S. May, *Collecting Cultures: Myth, Politics, and Collaboration in the 1948 Arnhem Land Expedition* (Lanham Maryland: AltaMira Press, 2010), xi-xx. See also A. Crowell, A. Steffian, and G. Pullar eds, *Looking Both Ways: Heritage and Identity of the Alutiiq People* (Fairbanks: University of Alaska Press, 2001); A. Crowell, R. Worl, P.C. Ongtooguk, and D.D. Biddison eds, *Living Our Cultures, Sharing Our Heritage: The First Peoples of Alaska* (Washington: Smithsonian Books, 2010).

Berlin Museum of Ethnology, or in James Clifford's description of Tlingit elders' telling of oral narratives inspired by objects at the Burke Museum, museum collections represent significant repositories of intangible forms of knowledge that are encoded in tangible objects.[23] Indeed, according to Christina Kreps, "Objects stand for significant traditions, ideas, customs, social relationships, and it is the stories they tell, the performance they are a part of, and relationships among people and between people that are more important than the objects themselves."[24] The responses of our Inuvialuit team members, similarly inspired by reconnection to their material heritage, were documented by Inuvialuit Communications Society producers and became a documentary that is featured in our virtual exhibit, called *A Case of Access*.[25] Moreover, beyond communicating the results of our workshop, our team began to explore the possibility of using digital tools to extend the experience of exploring the collection to more Inuvialuit peoples and the general public, and to create a forum within which Inuvialuit knowledge of the collection could be elicited, curated, and represented on Inuvialuit terms. Our delegation was small – necessarily so, primarily because of the cost of travel from Inuvik to Washington – meaning that only a few members of the large Inuvialuit community could participate in the interpretation of this valuable collection. At that time, Elder Albert Elias told us, "A lot of the objects that we saw, we haven't seen before. I think it is a living document: a living project," added Elias. "When we go back home and we do our presentations and we show these objects to schools and communities, their input is going to be very important too."[26] We decided to embark on the production of a dynamic virtual exhibit that would contribute to the revitalization of the MacFarlane Collection as a "living collection," hence the name of the site: *Inuvialuit Pitqusiit Inuuniarutiat: Inuvialuit Living History.*

23 A. Fienup-Riordan, "Yup'ik Elders in Museums: Fieldwork Turned on its Head," *Museums and Source Communities: A Routledge Reader*, eds. L. Peers and A.K. Brown (London: Routledge, 2003), 28-41; Fienup-Riordan, "Collaboration on Display: A Yup'ik Eskimo Exhibit at Three National Museums," *American Anthropologist* 101 no. 2 (2003): 339-358; J. Clifford, "Museums as Contact Zones," in *Routes: Travel and Translation in the Late Twentieth Century* (Cambridge, MA: Harvard University Press, 1997), 188-219.

24 C.F. Kreps, "Indigenous Curation, Museums, and Intangible Cultural Heritage," in *Intangible Heritage*, ed. L. Smith et al. (London: Routledge, 2009), 193-208 (197).

25 Inuvialuit Communications Society 2011.

26 M. Lepage, "Museums and Mukluks: Arctic Representatives Explore MacFarlane Collection," *Tusaayaksat* (Winter 2010): 29-37.

Digital Technology and Cultural Production

According to Eilean Hooper-Greenhill, "Visual culture within the museum is a technology of power. This power can be used to further democratic possibilities, or it can be used to uphold exclusionary values."[27] It was in this spirit of opening up their collections to ancestral owners that the Smithsonian Institution granted permission to the Inuvialuit Cultural Resource Centre to re-mediate and re-contextualize their MacFarlane Collection digital data, without limitation. Working with the developers of the Reciprocal Research Network, we used the RRN's API (Application Programming Interface) to appropriate images and catalogue information, a practice that I describe in more detail below[28] (see figure 10). The *Inuvialuit Living History* virtual exhibit in its present iteration is organized around the presentation of both objects in the MacFarlane Collection and multimedia documentation of our delegation's first encounter with the objects in Washington, DC. Further, it has been designed to function as an archive of user contributions, ongoing research activities, and community projects that are being developed as interest in the collection grows and as funding and resources become available. The exhibit has been created to be fully editable by our team so that the website itself can grow and change as priorities and interests shift over time.

In the course of production since 2009, we have conducted several major community consultations in the Inuvialuit Settlement Region, visiting with elders, community workers, and teachers and school children, each consultation raising new questions about the collection, access to it, ownership of it, its potential repatriation to the North, all of which have informed successive iterations of our exhibit design. Our team has rewritten curatorial descriptions of the objects, photographed undocumented objects, revised their classification categories, used semantic web and tagging to build new relationships among objects, records, and related media, and experimented with media licenses to denote a spectrum of approaches to media ownership and copyright. The elements of the virtual exhibit are presented below as representations of knowledge and relationships – representations of and between material and digital objects – as well as disciplinary and technological practices that are illuminated in the process of digital cultural production. They exemplify specific digitally mediated

Figure 10 Screenshot from *Inuvialuit Living History*

www.inuvialuitlivinghistory. ca. 2015

practices and collaborative approaches to virtual exhibit design that are contributing to a shift in control over ethnographic representation from heritage institutions to originating communities. For our project team, these elements of the exhibit point to the development of further research questions and methodologies that have yet to be determined by our project team in our work together in subsequent phases of the project.

The RRN's API

Inuvialuit Living History takes advantage of the increasingly standard network development tool, the API (Application Programming Interface), that allows developers to stream data from one source to another and to represent shared data in new contexts. APIs are used to create access to information architectures and data, but it is important to note that the structures of APIs – their design, which varies from institution to institution – both mediate and determine what access to data means.[29] Once the Smithsonian had made the MacFarlane Collection available to the Reciprocal Research Network, our team was able to use the RRN's API to take the Smithsonian's digital data and bring it into our own virtual exhibit. Via the RRN's API, we used the template for object record viewing and user contributions created by the developers of the Reciprocal Research

29 M. Ananny, *A New Way to Think About Press Freedom: Networked Journalism and a Public Right to Hear In An Age of "Newsware,"* (PhD thesis, Stanford University, 2011).

Network.[30] We then adapted the presentation of the MacFarlane Collection data to embed it in the context of our particular project and to address the Inuvialuit Cultural Resource Centre's goals for remediation of the collection and representation of the project: to make the collection accessible to Inuvialuit peoples, to represent the collection using categories and descriptions that were relevant to Inuvialuit experience, and to reinvigorate the collection through its reproduction in everyday life. The Smithsonian Institution's willingness to transfer control over representation of their data and to support Inuvialuit ownership of the collection in digital form represents an ongoing negotiation over ethnographic authority and cultural representation that I consider remarkable and a productive outcome of the project so far. For our team, the Reciprocal Research Network and the design of its API facilitated the re-contextualization of institutional data by our team members, shifting control of representation from the Smithsonian to members of the community of origin.

Categories and Classifications

Information associated with objects in the MacFarlane Collection represented information documented by Roderick MacFarlane at the time of collection and subsequent curatorial interpretation generated outside of the context of Inuvialuit cultural life. Our team decided that exhibiting the artefacts online required the re-classification of objects into types that were consistent with contemporary Inuvialuit identifications. Led by team member Charles Arnold, objects within these types were then assigned tags demarcating categories that more accurately describe relationships between objects in the collection based on their type (for example: mittens, harpoon, pipe), use (sea mammal hunting, sewing, adornment), materials (sinew, baleen, ivory), techniques of manufacture (cutting, scraping, lashing), and linguistic terms (in the Inuvialuktun dialect of the Anderson River region, Siglitun). Visitors to the virtual exhibit can search the collection using any number of these tags and generate results that differ from the collection's former institutional online presentation. The site's content management system creates new relationships between media; for example, photographs and videos documenting our trip to Washington, DC become related to object records; objects' records are accompanied by media documenting Inuvialuit engagement with the collection. A visitor's experience of the collection is determined by individual interest and priority, while the semantic

30 Rowley et al., "Building an On-Line Research Community."

relationships created between objects in the collection are flexible and overlapping, and will likely change over time as users contribute additional tags and contextual information. The reclassification and categorization of objects in the MacFarlane Collection – and the possibility that these classifications and categories will change over time in response to user contributions – represents a departure from the relatively static representation of collections data shared by the Smithsonian.

Curatorial Descriptions

Objects in the collection were accompanied by little information, and according to project team members, were often incorrectly identified or attributed. A central element of the project has been the researching and rewriting of curatorial descriptions of the objects, from general descriptions of object types to specific materials, manufacturing techniques, functions, Inuvialuktun terms, and associated traditional knowledge. Led by Charles Arnold, this has been a collaborative process involving Inuvialuit traditional materials specialist Darrel Nasogaluak and partnering curator Joanne Bird (although the goal of this element of the project is to involve as many elders and community members as possible as the project continues). Not wanting to erase previous institutional interpretations, the *Inuvialuit Living History* website follows the lead of the Reciprocal Research Network's presentation of institutional collections data and maintains the Smithsonian's original records, co-presented with contemporary interpretations. Each object record is linked back to institutional descriptions in the Reciprocal Research Network itself, so that users can see and evaluate different versions of the collections data. These newly drafted curatorial statements present an alternative to institutional representations of Inuvialuit cultural heritage, and they are in keeping with broader Inuvialuit expressions of contemporary identities and claims for self-definition.[31]

Web 2.0 and Control of User-Generated Content

The virtual exhibit's "object type" records include a feedback link that invites visitors to contribute their knowledge of the artefacts and to build the Inuvialuit Cultural Resource Centre's archive of Inuvialuit cultural

31 N. Lyons, "Inuvialuit Rising: The Evolution of Inuvialuit Identities in the Mackenzie Delta," *Alaska Journal of Anthropology* 7 no. 2 (2009): 63-79.

information and practices. While our web project welcomes the contri-
bution of user-generated content, our team made the decision to limit
un-moderated discussion about the objects and the project as a whole.
Users are encouraged to make un-moderated comments and contribu-
tions within the password protected Reciprocal Research Network (there
are links from within each object record in our site to that object within
the RRN). Expectations of openness, public contribution, and participa-
tion are tempered by a commitment to the Inuvialuit Cultural Resource
Centre's right to represent the collection on their own terms and within
their capacity to moderate and engage in public discussion on their own
website. While requesting feedback from visitors to the exhibit and from
project participants, user contributions will be directed to a committee
comprised of team members at the Inuvialuit Cultural Resource Centre and
Smithsonian curatorial partners, who will determine which contributed
information to make public and which to incorporate into the exhibit.
Web 2.0 functionality and principles of sharing and access are in this case
moderated in the spirit of greater control over cultural representation.
The process of deliberation on how to manage and maintain the site and
its contributions has opened discussion among members of our research
team about both opportunities and tensions associated with the virtual
repatriation of digital heritage, aspects of which our team will continue to
explore in subsequent phases of the project.

Media Licenses

Our process of bringing Smithsonian Institution data into a media space
"owned" by the Inuvialuit Cultural Resource Centre and combining it with
documentary media and other user-generated content, made it clear to our
team that our site needed to creatively represent variable approaches to
ownership of digital content contributed by a range of institutional, commu-
nity, and individual actors. To this end we created an upload system in which
media added to our exhibit such as photographs, videos, sound files, and
documents could be assigned a range of copyrights and ownership licenses.
These range from All Rights Reserved to specific identifiers and watermarks
(such as the Inuvialuit Communications Society, or Smithsonian Institution)
to Creative Commons (non-commercial, no-derivatives) 3.0 licenses. In
future iterations of the exhibit we hope to integrate Traditional Knowledge
(TK) labels developed by Jane Anderson and Kimberly Christen initially in the

context of the 2011 Mukurtu project and later at www.localcontexts.org.[32] While these TK labels are not legally binding, they draw attention to documentation of traditional and Indigenous knowledge as dynamic and collective forms of expression, for which ownership paradigms are not adequately represented by Western copyright schema. Our team hopes to experiment with the use of TK labels, applying them to appropriate media as Inuvialuit community members contribute to the exhibit. In creating the ability to assign a range of ownership designations to Inuvialuit and other media, we aim to develop a better understanding of the role of digital technologies in the context of Inuvialuit cultural documentation and revitalization initiatives, and in digital heritage safeguarding and Indigenous media production more widely. Acknowledging and representing the complexity of ownership of media and cultural documentation in the digital age is yet another way in which originating communities are asserting authority over the representation of their cultural heritage in museums.

Conclusion

In the course of bringing the *Inuvialuit Living History* project to life, our team has observed the beginnings of shifting institutional and community relationships in which technical interventions and digital experimentations are understood as central to our collaborative ethnographic process. During our first visit to the National Museum of Natural History to view the MacFarlane Collection in 2009, filmmakers from the Inuvialuit Communications Society documented the responses of the Inuvialuit delegation as they handled and discussed their ancestral objects. The filmmakers interviewed team members, including curator Stephen Loring, about their experience and hopes for the project, creating a record of our interactions. This video documentary now accompanies the digital collections records in the context of the *Inuvialuit Living History* website. The production of this documentary film, shot in the vast storage facility of the Smithsonian's Museum Support Center, represented the first of what would become a more complex digital representation of the MacFarlane Collection by our project team that includes contemporary engagements with these belongings.

The *Inuvialuit Living History* project, still a work in progress, constitutes an attempt to relate media objects and cultural knowledge in new ways, and

32 J. Anderson and K. Christen, "Traditional Knowledge Licensing and Labeling Website 1.0: localcontexts.org," *IPinCh. Intellectual Property Issues in Cultural Heritage*, 9 March 2012.

to communicate both the experiences of our Inuvialuit delegation with the MacFarlane Collection and the research questions and the methodological approaches to digital ethnography that have emerged in the context of our collaborations. The project is leveraging increasingly common developer tools, such as the API, re-framing institutional collections data, facilitating the creation of new and dynamic relationships between media objects, and testing paradigms for signaling ownership of digital cultural property. In this way, processes of digitization and virtual exhibit design practices are themselves productive sites for digital ethnography. Since the official launch of the *Inuvialuit Living History* project in 2012, we have continued with a new phase of our collective work in which we hope to better understand the effects of institutional collections digitization and Inuvialuit remediation. As we use the Smithsonian's digital data in ways not previously imagined by the institution, and indeed beyond institutional control,[33] we see digitally mediated practices in museums and originating communities opening spaces, both online and offline, for the practice of collaborative research that illuminates wider relations of power embedded in ethnographic and curatorial practices and new technologies.

Acknowledgements

My sincere thanks to *Inuvialuit Living History* Project team members Natasha Lyons, Catherine Cockney, Charles Arnold, Mervin Joe, Albert Elias, James Pokiak, and Stephen Loring. My thanks also to the other members of our delegation to the Smithsonian Institution: Helen Gruben, Karis Gruben, Shayne Cockney, Freda Raddi, Brett Purdy, Dave Stewart, and Maia Lepage. The *Inuvialuit Living History* Project is a production of the Inuvialuit Cultural Resource Centre, Inuvik, NWT. The documentary *A Case of Access,* referenced in this paper and featured in the virtual exhibit, was produced by the Inuvialuit Communications Society. Thank you to software developers Ryan Wallace and Nicholas Jakobsen (Culture Code), to Carrie Beauchamp at the Smithsonian Institution. Thank you to Joanne Bird, and media production assistants Irine Prastio and Karen Truong at Simon Fraser University's School of Interactive Arts and Technology. Special thanks to Susan Rowley at the Museum of Anthropology at the University of British Columbia, and to the Reciprocal Research Network Steering Committee (Susan Rowley, Dave Schaepe, Leona Sparrow, Andrea Sanborn, and Sarah

33 Boast, "Neocolonial Collaboration," 67.

Holland) for consistent support. Thank you to Mike Ananny at Microsoft Research New England, and to Oliver Neumann. This chapter represents some of my initial thoughts on the website production process and the knowledge that has been produced in the course of our collective work together. Elements of this chapter were rewritten in a co-authored paper for the proceedings of the 2012 *Museums and the Web* conference.[34]

34 K. Hennessy, R. Wallace, N. Jakobsen, and C. Arnold, "Virtual Repatriation and the Application Programming Interface: From the Smithsonian Institution's MacFarlane Collection to Inuvialuit Living History," in *Museums and the Web: Proceedings 2012*.

Conclusion[1]

Chiel van den Akker

In his keynote address at an annual meeting of the Association of American Museums in the early 1980s, the American philosopher and former art dealer Nelson Goodman, who had been unable to "summon enough discretion to decline an invitation," told his audience of museum professionals that the major mission of museums is to make works work. This he takes to be the following:

> Works work when, by stimulating inquisitive looking, sharpening perception, raising visual intelligence, widening perspectives, bringing out new connections and contrasts, and marking off neglected significant kinds, they participate in the organization and reorganization of experience, and thus in the making and remaking of our worlds.[2]

Goodman admits that different types of museums face different obstacles in their efforts to accomplish this noble task, but all museums should make their works work.

Four decades later, at the annual meeting of the International Association of Museums in a Digital Culture, a holograph of Goodman delivered an almost identical keynote address (as far as I could tell, only the phrase "in a digital culture" was now and then inserted into the talk, acoustically indistinguishable from Goodman's own voice). The organizers of this wonderful meeting happened to have laid their hands on a tape recording of the original address and had been able to digitize it and have it spoken out loud by a digitally rendered holograph. They chose this, as they explained on the conference's website, because they believed that there was no reason to depart substantially from the address that Goodman gave in the early 1980s. One reason is that he had hardly anything to say then on *how* the museum professional is to make works work, so regardless of the many and at times profound changes in that profession in the last four decades or so, his talk did not touch upon his proposition that museums ought to make works work, which the organizers believed was still sound. But more importantly,

1 Some of the issues raised here are a response to the helpful questions of the reviewers of this volume.

2 N. Goodman, *Of Mind and Other Matters* (Cambridge, MA: Harvard University Press, 1984), 179-180.

the organizers explained, Goodman's address appears to be more spot on in the early 2010s than it was in the 1980s. What follows supports this claim.

As an attendee at the meeting, the keynote address reminded me of this volume, for as the contributions show, digital technology enhances the experience of exploring museum collections, bringing out new connections and contrasts between objects, as well as allowing new involvements and opportunities for co-creation and co-curation, and the sharing and creation of knowledge, both on-site and online. Museums and artists in our post-industrial world are well acquainted with the aim of delivering museum experiences and have increasingly held themselves accountable for it,[3] which in turn reminded me of the work of Ross Parry, who among others claims that the shift from object-centered to experience-centered design that he believes has taken place in the museum is supported by digital technology.[4] I was also struck by Goodman's idea that museums should encourage "inquisitive looking, sharpening perception, [and] raising visual intelligence," for central to this volume is the claim that information technology is well equipped to support precisely that, and again both on-site and online.

Goodman emphasizes that such encouragement does not single out ocular perception as the key to what the museum experience is all about; it rather serves understanding. He writes:

> Works work when they inform vision; *inform* not by supplying informa-tion but by *forming* or *re*-forming or *trans*forming vision; vision not as confined to ocular perception but as understanding in general.[5]

I take it that few would disagree with the view that the main reason why we have museums is that they advance understanding by forming and broadening our vision. To be sure, not only museums advance understand-ing: the sciences, the arts, libraries, galleries, concert halls, documentaries, theaters, and zoos do too. What sets the museums apart from these other institutions is that they collect, research, and exhibit material objects and are responsible for their preservation for future generations.[6]

3 H. Hein, *The Museum in Transition: A Philosophical Perspective* (Washington, DC: Smithso-nian Books, 2000), 5.

4 R. Parry, *Recoding the Museum: Digital Heritage and the Technologies of Change* (London: Routledge, 2007), 81.

5 Goodman, *Of Mind*, 180.

6 There are online museums with no counterpart in the real world. But if they are to be properly called museums, the objects they showcase must also be collected, preserved, and researched.

Museums are not only storehouses of valuable and well-researched objects, a selection of which is on display on-site and online; they are sociocultural institutions, as has been well argued by many scholars, giving us a sense of what there is and how that is to be valued and understood, relative to the society we or others live or have lived in. Since the meaning of an object depends on the interpretative framework within which it is placed (e.g. a master narrative, set of ideas, system, database etc.), a symbolic system that functions as a frame of reference, as Goodman would have it,[7] the technology used to access and display objects has political implications inasmuch as it is used to "open or close possibilities for individuals, groups or communities,"[8] as Eilean Hooper-Greenhill argued. Some authors in this volume showed how digital technology allows museums to host and empower new communities, giving them partial control over the meaning of the museum collection, thus affecting how museums function as sociocultural institutions.

The conclusion of all of this, and of this volume, is that digital technology *enhances* and *extends* the museum experience and function rather than replacing them with something else. This conclusion is, I think, immediately plausible when we think about such things as content management systems, online access to collections, interactive media art installations, user-generated content, and the use of mobile and other digital devices in museums that support the display of objects. The conclusion does not contradict the fact that the access to and experience of art and heritage within museums is changing in a digital culture, as this volume showed, for museums and artists have always sought to provide new experiences and ways to be meaningful and of interest to the public. If digital technology should enhance and extend the museum experience and function, we know in a general sense what the museums and their on-site and online visitors may gain by it, and each chapter in this volume affords some concrete examples of this. Here I want to make several additional general points, including some of the risks involved, without revisiting what has already been said in this volume.

Crucial is, I think, that if online access is an extension and enhancement of the on-site museum experience, we are not to contrast the on-site experience and the online experience. This is not to say that the artwork or other artefact that works on-site in a digitally unmediated environment does so in an extended and enhanced manner in a digitally mediated environment. Clearly,

7 N. Goodman, *Ways of Worldmaking* (Indianapolis: Hackett Publishing Company, 1978).

8 E. Hooper-Greenhill, *Museums and the Interpretation of Visual Culture* (London: Routledge, 2000), 8. See also ibidem 148.

the *appreciation* of art and other objects on-site and in museums is very different from the appreciation of their digital reproductions. But precisely for this reason we should not even want to replicate an on-site experience online (and vice versa). The online access to museum collections is no substitute for an on-site visit and should not be meant to be so. Goodman's keynote speech sheds some further light on this; at one point he remarks that the museum's shop and sales desk may, to some extent, prolong and enhance the museum experience.[9] They do so inasmuch as the reproductions, catalogues, and other scholarly publications that are on sale serve as a reminder of the visit (so these items are clearly no substitute for what they represent and inform about). We might argue that this function is also provided by online access. To be sure, in our digital culture we often do not first go to a museum and use a digital device afterwards to remind ourselves of our visit (although museums try to encourage such online revisits, for example by having visitors take a picture in some setting which can be viewed afterwards online). However, the point is that museums may extend their influence outside the museum building, and this influence may be exponentially increased with the help of digital technology, thus enabling the visitor to develop a more refined and educated sense of the aesthetic, historic, scientific, and cultural value of the world they inhabit. Is that not what we mean when we talk about advancing understanding through museums? Moreover, as a result, the desire to experience art and objects on-site may increase.

Nevertheless, the distinction that Goodman draws in the second quotation above between supplying information and understanding (in the sense of forming, re-forming, and transforming vision) does point to a potential risk.[10] In our digital culture, the use of digital technology by museums may turn the museum into another "channel of information," as Didier Maleuvre in a rather sombre note observes. Although he only discusses art, his observations concern the museum sector at large. In what he refers to as a quick-image society,

> we forget that images can also be landscapes – long in traveling through, slow to unravel, as deep as the horizon – and not just signposts. This

9 Goodman, *Of Mind*, 184.
10 On the distinction between information provision and interpretation support in a more practical sense and in the context of the online access to museum collections, cf. C. van den Akker, M. van Erp, L. Aroyo, A. van Nuland, L. van der Meij, S. Legêne, and G. Schreiber, "Evaluating Cultural Heritage Access on the Web: From Information Delivery to Interpretation Support", in *Proceedings of the 5th International Conference on Web Science (WebSci'13)* Paris, France, May 2-5 2013.

experience is now jeopardized by the selective, truncated mode of know-
ing typical of hurried, technological society: the quick scan, the plucking
of data, the looking only for what is wanted.[11]

Perhaps Maleuvre is right about the tendency of museums to inform their
visitors rather than stimulating "inquisitive looking, sharpening perception,
raising visual intelligence, [and] widening perspectives." But observations
such as Maleuvre's only further support the conclusion we arrived at here.
What he fears is that rather than extending and enhancing the museum
experience and function, modern technology replaces it with something
else, turning the museum object into an information carrier. This volume
suggests, however, that even though all the information available about
some object in a museum collection is literally at our fingertips if we know
how to use the appropriate devices and applications – which in itself is a
good thing – such information is not provided to prevent us from having
the sort of museum experiences that Maleuvre believes will be forgotten
(he himself clearly has not forgotten). To be sure, this response leaves his
fear intact. However, if we agree with Maleuvre that the contemplative
experience of art is jeopardized in a "quick-image society," it does not follow
that digital technology is to blame for it, for there is no a priori reason
why digital technology should be used to deprive us of this contemplative
experience and replace it with something else. We may further add that
browsing an online collection does not simply inform us about the objects in
the collection as we quickly scan through them: browsing is also an intuitive
and affective experience, and asks for an engagement with the collection
that extends beyond the objects and their description on view, drawing
out new contrasts and making new connections, widening perspectives,
raising visual intelligence, as this volume shows, and thus affecting how we
see and experience other artefacts than those that happen to be displayed
on our screen.

Maleuvre's sombre note reminds me of a disturbing commercial for
Samsung that aired a few years ago. The commercial shows a teacher visiting
a museum of natural history with her class, and the children are com-
pletely bored as they stare at the skeleton of a dinosaur. In the next scene,
the teacher takes out her Samsung tablet and shows a roaring dinosaur
animation, and the children get really excited. (I do not believe that this

11 D. Maleuvre, "A Plea for Silence: Putting Art Back into the Art Museum," in *Museum Philoso-
phy for the Twenty-First Century*, ed. Hugh Genoways (Lanham: Altamira Press, 2006), 161-176
(168).

commercial comes even close to how children behave in a natural history museum, which is not a criticism of the commercial, for commercials tell us what we should buy rather than what the world is like). It is not the use of a device showing an animation that is disturbing, and there is nothing wrong with the use of augmented reality in museums. The disturbing thing is that the commercial suggests that digital technology replaces the museum experience and function with something else, which makes the museum redundant, and that, according to the commercial, is a good thing.

The problems that museum professionals face every day are not solved by reaffirming the major mission towards which their work should contribute. However, in addition to contributing to the debate on how art and heritage become meaningful in a digital culture, we hope that the chapters in this volume afford some guidance and inspiration for museum professionals to reflect on their own practices in this digital culture. If it is true that museums should make their works work and digital technology should enhance and extend the museum experience and function rather than replacing them with something else, we know the criteria with which to assess whether the changes that digital technology allows and brings about are beneficial to museums and their visitors or not. One important consequence is that we should think of digital technology in terms of *means* rather than in terms of goals. Advancing understanding is the ultimate goal of museums, and part of such advancement is achieved by using digital technology on-site and online. If there is one major reason for museums to embrace this new technology, then this is it.

Notes on Contributors

Anne Beaulieu is program manager of Energysense, a comprehensive knowledge infrastructure with information on energy consumption, attitude and behavior in households. She joined the University of Groningen in 2011 following several years as senior research fellow at the Royal Netherlands Academy of Arts and Sciences (KNAW), notably at the Virtual Knowledge Studio for the Humanities and Social Sciences. A dominant theme in her work is the importance of interfaces for the creation and circulation of knowledge. Past research projects focused on data sharing, knowledge networks, and visual knowledge. Anne has also done extensive work in digital humanities, on new (ethnographic) research methods, and on ethics in e-research.

Sarah de Rijcke is senior researcher at the Centre for Science and Technology Studies (CWTS), Leiden University. Her current research in evaluation studies examines interactions between research assessment and practices of knowledge creation. This program is situated at the intersection of science and technology studies and the sociology and anthropology of science. Before coming to Leiden, Sarah held a postdoctoral position at the Virtual Knowledge Studio in Amsterdam where she participated in the research project Network Realism with Anne Beaulieu. Her PhD research focused on the role of visual representations of the brain in the production of neuroscientific knowledge.

Christina Grammatikopoulou holds a PhD in art theory from the University of Barcelona. She is managing editor of the art journal *Interartive*. Her research on art and information technologies is currently being carried out in Denmark as a visiting scholar at Aarhus University, and in Spain as a member of the group "Art, Globalization, Interculturality" at the University of Barcelona. Christina is also an academic advisor at the Transart Institute and an assistant professor at the Open University of Cyprus.

Kate Hennessy is a cultural anthropologist and assistant professor specializing in media at Simon Fraser University's School of Interactive Arts and Technology (SIAT). As the director of the Making Culture Lab at SIAT, her research explores the role of digital technology in the documentation and safeguarding of cultural heritage and the mediation of culture, history, objects, and subjects in new forms. Current projects include the collaborative

production of virtual museum exhibits with Indigenous communities in Canada; the study of new digital museum networks and their effects; and the intersections of anthropology and contemporary art practices.

Susan Legêne is professor of political history at the Vrije Universiteit Amsterdam (VU) and one of the program leaders of the research cluster Global History, Heritage, and Memory of the VU-research institute CLUE+ (see www.ghhpw.com). She participated in the NWO-funded research teams of AGORA (2009-2014) and the Nl-eScience Centre project BiographyNET (2012-2016), both covering computer science, computational linguistics, history, museums, and archival practices. Before joining the VU, she was head of the curatorial department of the Tropenmuseum in Amsterdam. Recently she coedited the volume Susan Legêne, Bambang Purwanto, Henk Schulte Nordholt eds., *Sites, Bodies and Stories: Imagining Indonesian History* (Singapore: NUS Press, 2015).

Cecilia Lindhé is senior lecturer in comparative literature and director of the Centre for Digital Humanities at Gothenburg University. She works continuously with issues that involve digital research infrastructure, information technology, and pedagogy. Her current research spans ancient and medieval rhetorical and aesthetic theory in relation to digital representation of cultural heritage and digital literature and art. Her recent publications include "Medieval Materiality through the Digital Lens," in *Between Humanities and the Digital*, P. Svensson and D. Goldberg eds. (Cambridge, MA: MIT Press, 2015), 193-204.

Martijn Stevens received his PhD degree with a thesis on the conceptual shifts that result from the digitization of art museums and heritage institutions. Currently Martijn is assistant professor at the Department of Cultural and Literary Studies at Radboud University in Nijmegen. He studies contemporary culture with a special interest in the social and organizational dimensions of cross-sector collaboration, knowledge exchange, and entrepreneurship in the arts, the cultural sector, and the creative industries. Before turning to academia, he worked at a center for art and media technology.

Serge ter Braake earned his PhD in medieval history in 2007 at Leiden University. Between 2007 and 2012 he was a researcher and editor for the Digital Monument to the Jewish Community in the Netherlands. He has written books on the political and cultural history of Holland in the

sixteenth century, the economic role of Dutch Jews in the leather industry, and the restitution of real estate after the Second World War. Since 2012 he has been a postdoctoral researcher in the field of digital humanities, first at the Vrije Universiteit Amsterdam (2012-2015), currently at the University of Amsterdam.

Chiel van den Akker is assistant professor theory of history in the Department of Art and Culture, History and Antiquities of the Vrije Universiteit Amsterdam. After receiving his PhD in philosophy from Radboud University Nijmegen in 2009, he became a postdoctoral researcher at the Vrije Universiteit Amsterdam in the NWO-funded AGORA project (2009-2014), which was concerned with the development of methods and techniques to improve access to and interpretation of online museum collections. Chiel's work is concerned with the understanding of the past in a digital culture and the nature of historical representation.

Index

Printed and bound by CPI Group (UK) Ltd, Croydon, CR0 4YY

15/12/2022

03173623-0001